British Art Show 7
In the Days of the Comet

Nottingham	23 October 2010 – 9 January 2011
	New Art Exchange
	Nottingham Castle Museum
	Nottingham Contemporary
London	16 February – 17 April 2011
	Hayward Gallery
Glasgow	28 May – 21 August 2011
	Centre for Contemporary Art
	Gallery of Modern Art
	Tramway
Plymouth	17 September – 4 December 2011
	Peninsula Arts
	Plymouth Arts Centre
	Plymouth City Museum and Art Gallery
	The Slaughterhouse, Royal William Yard

SOUTHBANK CENTRE HAYWARD PUBLISHING ARTS COUNCIL ENGLAND

British Art Show 7

Lisa Le Feuvre and Tom Morton

In the Days of the Comet

Published on the occasion
of the exhibition

British Art Show 7
In the Days of the Comet

Exhibition tour:

23 October 2010 – 9 January 2011,
Nottingham

16 February – 17 April 2011,
London

28 May – 21 August 2011,
Glasgow

17 September – 4 December 2011,
Plymouth

Exhibition curated by
Lisa Le Feuvre and Tom Morton
Exhibition Organiser
Isobel Harbison
Assistant Curators
Vanessa North and Hattie Spires

Published by Hayward Publishing
Southbank Centre
Belvedere Road
London, SE1 8XX, UK
www.southbankcentre.co.uk

Art Publisher
Mary Richards
Publishing Co-ordinator
Faye Robson
Sales Manager
Deborah Power
Catalogue designed by
John Morgan studio
Printed in Belgium by
Die Keure

Texts (pp. 25–181) by
Lisa Le Feuvre (LLF)
Elizabeth Manchester (EM)
Tom Morton (TM)

A catalogue record for this book is
available from the British Library

ISBN 978 1 85332 286 0

Distributed in North America,
Central America and South America
by D.A.P. / Distributed Art
Publishers, Inc., 155 Sixth Avenue,
2nd Floor, New York, NY 10013
T +212 627 1999
F +212 627 9484
www.artbook.com

Distributed outside North, Central
and South America by Cornerhouse
Publications, 70 Oxford Street,
Manchester, M1 5NH
T +44 (0)161 200 1503
F +44 (0)161 200 1504
www.cornerhouse.org/books

Cover: Milena Dragicevic,
Supplicant 00, 2009 (detail)

one of the country's most vibrant centres of artistic production with a strong recent history of city-wide collaboration in presenting the biennial Glasgow International. In returning to Glasgow for the first time since 1990, we are pleased to be working with colleagues in three of that city's major contemporary art spaces, each with an ambitious and adventurous international programme and well-established relationships to the art community and the wider public.

Plymouth, the final destination for the tour, will be hosting the *British Art Show* for the first time, where its presentation is underpinned by the focus and commitment of the Plymouth Visual Arts Consortium, a recently founded collective whose aim is to raise the profile of contemporary art across Plymouth and the South West of England. In partnership with Urban Splash, PVAC is using the exhibition to launch an exciting new cultural venue, The Slaughterhouse, within the historic Royal William Yard.

We are deeply indebted to the curators for their passionate commitment and to the artists, who have given us an exhibition of tremendous quality. Thanks are due also to Exhibition Organiser Isobel Harbison, Assistant Curators Vanessa North, Hattie Spires and their team, for their indefatigable enthusiasm, efficiency and good humour in bringing this complex show to fruition. At Hayward Publishing, Mary Richards, Amy Botfield and Faye Robson have produced this publication with immense skill and dedication, and we are grateful to John Morgan for his imaginative and innovative design. A full list of acknowledgements appears on pp. 191–92 of this catalogue.

Finally, as always, our gratitude goes to Alan Bishop, CEO of Southbank Centre and Jude Kelly, Artistic Director of Southbank Centre, for their enthusiastic support of this national exhibition.

Roger Malbert
Senior Curator, Hayward Touring

Ralph Rugoff
Director, Hayward Gallery

Note on the Subtitle

In the preface to his novel London Fields *(1989), the British writer Martin Amis (or perhaps a character who shares his initials) reminds us that books have 'two kinds of title – two grades, two orders. The first kind of title decides on a name for something that is already there. The second kind of title is present all along: it lives and breathes, or it tries, on every page.' Substitute words for works, pages for displays, and the same is true of the names given to exhibitions.* British Art Show 7 *is the first kind of title.* In the Days of the Comet *is the second.*

British Art Show 7: In the Days of the Comet *looks to art made in the period 2005–10, paying particular attention to the ways in which artist make use of histories – be they distant or proximate, longingly imagined or all too real – to illuminate our present moment. While current scientific theory posits that comets are nothing more than elliptically orbiting clumps of dust, ice and gas, utterly indifferent to our affairs, they remain powerful reminders of the way in which our species has attempted to understand experience through the measuring of time, the writing of history, the belief in cosmological influence, and the notion of a deterministic universe. The comet alludes here to the measuring of time, to historical recurrence, and – in the commonly counterclockwise movements of these heavenly bodies around the sun – to pocket universes and parallel worlds. The comet is a sign mistaken for a wonder, be that cataclysm or rapture, and a figure of looping obsession. It is something that is always with us, no matter that it is sometimes far out of sight.*

The subtitle of the seventh British Art Show is taken from H.G. Wells's 1906 novel In the Days of the Comet, *set a century ago in 1910, the date of Halley's Comet's last-but-one apparition. The British socialist and science-fiction writer imagines the appearance of a comet over the United Kingdom, which releases a green gas that creates a 'Great Change' in all mankind, turning it away from war and exploitation and towards rationalism and a heightened appreciation of beauty. Notably, this shift in understanding is achieved not through human agency, but through an ineffable alien force. What is significant about Wells's title, however, is that the 'days' to which it refers are not only those of an enforced utopian transformation, but the whole of recorded history. The comet's recurrent nature, and its orbiting of the same sun as the Earth, draws together the past, present and perhaps even the future too. Britain has always lived 'in the days of the comet'.*

Lisa Le Feuvre & Tom Morton, London, 2010

Tom Morton What Will Survive of Us

Art has only one chance to be contemporary, a short spell in which it exists within the culture in which it was made. For all that specific works persist through time (and in some cases only make their significance felt long after their moment of manufacture), they shed the days that first enveloped them like you or I shed skin – invisibly, involuntarily and with no hope of reversal.

In his poem 'An Arundel Tomb' (1964), Philip Larkin meditates on a piece of medieval funerary sculpture from Chichester Cathedral that depicts an 'earl and countess' lying 'side by side', 'their faces blurred' by the passing of the centuries, their Latin epitaphs inscrutable to all but scholars and priests. He records his 'sharp and tender shock' on noticing that the figures are holding hands, a detail that is not the work of the original sculptor but a later Victorian addition. Who these people were, what feelings passed between them, the particular contours of the faith with which they met the sure knowledge of their deaths – if this information reaches us at all, it does so through the filter of temporal distance, and the fantasies we wind around the past. Interviewed in 1981, the poet related how a friend had visited the Cathedral, where he read in a guidebook that 'a poem was written about this tomb by Philip Spender'. 'Muddle', as Larkin puts it, 'to the end'.[1]

To be invited to co-curate the *British Art Show* (*BAS*) is to be invited to think about time. Like its six earlier incarnations, *BAS7* is concerned with art produced over the previous five years, in our case the period 2005–10. To a degree, this particular timeframe speaks of nothing more meaningful than the fact that the first of these quinquennial exhibitions opened in 1979 – art, let alone history, does not organise itself into distinct and internally coherent periods of half a decade. The problem of drawing boundaries around a given moment, especially one we identify as 'contemporary', is eloquently stated by Simon Martin in his film *Carlton* (2006). Towards the end of this essayistic exploration – via a postmodern shelving unit – of how radical aesthetics enter the vernacular, a voiceover states that 'Nobody knows exactly when "today" actually happened. Maybe "today" occurred with the closure of Andy Warhol's Factory, or with the growth in the secondary market for avant-garde furniture, [or at] the point when one notices elderly people eating in McDonald's for the first time or realise that you know the lyrics to *West End Girls* by the Pet Shop Boys by heart.' While each of the works in *BAS7* was completed during the five-year-long 'today' of the exhibition's temporal remit, it is perhaps more useful to think of

1. Christopher Ricks, 'Like Something Almost Being Said', in *Larkin at Sixty* ed. Anthony Thwaite, Faber & Faber, London, 1982, p. 122.

them belonging to the nebulous 'today' that Martin describes, or even to the day after that.

This is not to say that the last half-decade is without its distinguishing features. When *BAS6* opened in 2005, the White House had never known a black President and China had not hosted the Olympic Games. Climate-change denial was still part of mainstream political discourse, and YouTube and Facebook were modest startups. Many nations in what we used to call the First World were caught up in a dizzy collective fantasy of perpetual economic growth. In short, these and many other things have changed. While the works in *BAS7* do not, for the most part, deal directly with the headline developments of the last five years (and not a single work in the show could be confused with a newspaper leader, a straight documentary or a protestor's placard), each of them is a report from a particular time – something very different from a passive cultural artifact or historical deposit. This exhibition argues that there may be more to be learned about the contemporary world from, say, the paintings of Varda Caivano (with their Beckettian resolve to 'fail better' at the impossible task of fixing form, line and colour), the absurdist satires of Nathaniel Mellors (in which language becomes a technology of self-enslavement and self-abasement), the films of The Otolith Group (who recover fantasies of the future from the past to illuminate our present) or the sculptures of Roger Hiorns (which have, at their core, the question of what it means to act, to *do*) than any number of works of point-and-click social reportage.

To be invited to co-curate the *British Art Show* is also, of course, to be invited to think about place. Any exhibition that attempts to foreground a particular nation – especially a nation forged largely through internal and external colonialism – is potentially problematic. 'Britain' and 'British' are complex, contested and in the end not terribly useful notions, and any attempt to fix their meaning risks reductive thinking. Given the global dimension of much contemporary art practice, it was obvious from the start that the basic criteria for the inclusion of a work in *BAS7* should be as broad as possible: that it was made by an artist working in Britain, or that it was made by a British artist working abroad. Far harder was negotiating the 'Britishness' of the *British Art Show*, which is to say, the fact that it is unavoidably staged in a particular set of territories that have a particular set of (often occluded) histories. How might this be positively embraced? One answer lies in imagining Britain as a geographically and psychologically unfamiliar place – somewhere between the alien island approached by Roman sailors at the Thames' mouth in the opening pages of Joseph Conrad's novel *Heart of Darkness* (1899) and the disorienting landscape traversed by the Candide-like protagonist of Lindsay Anderson, Malcolm

McDowell and David Sherwin's film *O Lucky Man!* (1973). Not somewhere wholly known, then, but rather somewhere to (re)discover, both through the work of the artists featured in *BAS7*, and its curatorial framing.

In the novelist G.K. Chesterton's 1908 work of Christian apologetics *Orthodoxy*, he writes that 'I have often had a fancy for writing a romance about an English yachtsman who slightly miscalculated his course and discovered England under the impression that it was a new island in the South Seas' and who 'planted a flag on [a] barbaric temple which turned out to be the Pavilion at Brighton'.[2] Although this 'romance' remains unwritten, even in synopsis it suggests a potentially fruitful misunderstanding, in which the imperial beast realises that its uncontrollable greed has led it to bite down hard on its own tail. To walk the world we know as a stranger, or to re-imagine it in an unfamiliar form, is to discover it (and ourselves) anew.

In *BAS7*, the paintings of George Shaw revisit the Coventry council estate on which he grew up, transforming it into a visionary landscape, while Steven Claydon's *Trom Bell* (2010) tolls for a London borough that never was, and Charles Avery's ongoing 'Islanders' project describes the topology and cosmology of an imaginary island that, but for its strange inhabitants and stranger logic, might be a composite of Hackney, Rome, Edinburgh and Avery's childhood home, the Scottish Isle of Mull. The oldest artist in *BAS7*, Alasdair Gray employs a fairground mirror version of Glasgow in his novel *Lanark* (1980) to reflect on the real city, while the youngest, Tris Vonna-Michell, has journeyed to the exhibition's four civic venues to develop a fractured travelogue in which fact and fiction blur. A little later in *Orthodoxy*, Chesterton asks: 'How can we contrive to be at once astonished at the world and yet at home in it? How can this queer cosmic town, with its many-legged citizens, with its monstrous and ancient lamps, how can this world give us at once the fascination of a strange town and the comfort and honour of being our own town?'[3] Forgetting, perhaps, Chesterton's accent on 'comfort and honour' (these are not comfortable or honourable times) the parallel realms evoked by these contemporary British artists might go some way to answering his question.

Beyond the givens of time and place, Lisa Le Feuvre and I were free to choose which artists would feature in *BAS7*. We quickly established two ground rules. The first was that we must firmly agree on the list – so no trading the inclusion of 'X' for the inclusion of 'Y'. The second was that the only justification for an artist's appearance in the show was the strength of his or her work – so no special pleading. While we did not set ourselves a target number of participants, we were aware that we wanted to spend time in dialogue with everybody we selected. In the end we settled on 39 artists and artist

2. G.K. Chesterton, *Orthodoxy*, The Bodley Head, London, 1908, p. 2.
3. Ibid, p. 3.

groups, a large enough number to make for a substantial show, while keeping the possibility of fruitful discussion open. Medium was something we considered in terms of its relationship to particular practices and ideas rather than the overall 'balance' of the list, but we seem to have arrived, without quite trying to, at an exhibition that could be pretty much equally construed as an argument for the current strength of sculpture, painting, performance, film, video, drawing, installation and several points in between. (Photography features rather less, and practices that are usually grouped under the unsatisfying term 'participatory' not at all.)

We were keenly aware of the *BAS*'s history of reception. Despite the nuanced approach taken by several of its previous curatorial teams it has often been understood as an exhibition that might provide a definitive or evenhanded generational survey. The first of these is impossible (authoritative, maybe, but *definitive?*). The second is also impossible (somebody, somewhere, will always perceive an imbalance in the selection, and if it *were* possible it would run a high risk of being stultifying worthy and dull). We took several measures to sidestep such expectations. *BAS7* features artists born in the 1930s, '50s, '60s, '70s and '80s. It also features three major artists who have appeared in previous iterations of the show – Sarah Lucas and Wolfgang Tillmans in *BAS5* in 2000, and Roger Hiorns in *BAS6* in 2005 – each of whom were selected on the grounds that they are currently making the best work of their careers, the significance of which is yet to be fully absorbed into the bloodstream of the wider culture. However, the clearest signal that we want *BAS7* to be understood as more than a generational survey is our decision to give the exhibition a subtitle: *In the Days of the Comet.*

In the Western tradition, comets have long been understood as harbingers of change. The first recorded sighting of Halley's Comet over these islands dates from 1066 on the eve of the Norman invasion, when it was described as a 'haired star'[4] in *Anglo-Saxon Chronicle*. In the same year, Eilmer of Malmesbury, an English Benedictine monk best known for his attempts to fly with the aid of mechanical wings, is recorded as having greeted the comet with the words:

> *You've come, have you? [...] You've come, you source of tears to many mothers, you evil. I hate you! It is long since I saw you; but as I see you now you are much more terrible, for I see you brandishing the downfall of my country. I hate you!*[5]

It wasn't until 1705 that the English astronomer Edmund Halley established what Eilmer of Malmesbury had intuited: that far from being a one-off event, the comet passes by the Earth once every 75–76 years, and might be glimpsed twice during a human lifetime. Two years later, in 1707, the Act of Union joined the Kingdom of England and the Kingdom of Scotland into a single Kingdom of Great Britain. British

4. *The Anglo-Saxon Chronicle*, ed. Michael James Swanton, Routledge, 1998 edition, p. 195.
5. William of Malmesbury, *Gesta regum Anglorum / The History of the English Kings*, ed. and trans. R.A.B. Mynors, R.M. Thomson, and M. Winterbottom, 2 vols., Oxford Medieval Texts, Oxford, 1998–9, p. 121.

history, then, may be said on a number of different levels to take place 'in the days of comet'. Halley's Comet was last visible to the naked eye from Earth in 1986, the year of the deregulation of the British banking sector, commonly known as Margaret Thatcher's 'Big Bang'. Its next apparition is expected on 28 July 2061. Despite this comet's close association with Britain in our national consciousness, it has of course been glimpsed in countries across the globe (the earliest recorded sighting dates from 164 BC, and is set down in two fragmentary Babylonian tablets now owned by the British Museum[6]). A comet is not something that can be bound by national borders. The title *British Art Show 7: In the Days of the Comet* is intended to be read with this fact in mind.

Outlined in the 'Note on the Subtitle' that appears in this book's opening pages, our curatorial approach is less concerned with imposing a theme than providing a set of coordinates and method of navigation. Here, interpretations of celestial objects such as Halley's Comet, as well as aspects of their physical behaviour, suggest approaches to the works in the exhibition. The comet's recurrence through time points to Maaike Schoorel's mobilisation of traditional genres of painting, Luke Fowler's revisiting of the legacy of 1960s and 70s Structuralist filmmaking, Anya Kirschner and David Panos's appeal to highly coded cultural products from the past for information on the artifices of the present, and Matthew Darbyshire's repurposing of display strategies from the history of exhibition design. As a temporal measure, the comet finds a match in Christian Marclay's film *The Clock* (2010) and Keith Wilson's sculpture *Calendar* (2010–11), while the distance between the fantasy that comets are a powerful influence on earthly life and the fact that they are nothing more than flaming balls of space debris speaks to the sculptures of Brian Griffiths and Mick Peter, which turn on the comedy and pathos of thwarted dreams, and of pressing on regardless in blind denial of the void.

The shift from a cosmological to a material reading of comets maps on to the paintings, prints and chandeliers of Cullinan Richards, in which narrative is always being overtaken by pure *stuff*, and comets' mineral indifference to human affairs chimes with the autonomous technology presented in Elizabeth Price's film *User Group Disco* (2009). Halley's Comet charts a retrograde orbit, moving around the Sun in the opposite direction from the Earth, and we might imagine it as a parallel world or a site of fiction, of the type presented by Olivia Plender, Craig Burnett and Nick Santos-Pedro in their project *The Lost Works of Johan Riding* (2010–ongoing). Perhaps most strikingly of all, the comet presents itself to us in several different forms. It is a far-off light hanging static in the sky, then a line, and then a moving image. Up close, it is solid object, but one that glories in its fizzing tail.

6. G. Kronk, *Cometography*, vol. 1, Cambridge University Press, Cambridge, 1999, p. 14.

Visually, it shares attributes with painting, drawing, film, sculpture and performance. It is also a story, and an idea. Like the best art, it never settles on being just one thing.

H.G. Wells's novel *In the Days of the Comet* (1906), from which we borrowed *BAS7*'s subtitle, is usually classified as a utopian fiction, but there are casualties on the road to the Eden it describes. The first is human agency – our species does not chose to undergo the 'great change' that turns us from selfishness and violence towards altruism and peace, but has it forced upon us by the apparition of a comet that releases a mysterious green gas into the atmosphere, sending us into an instant sleep from which we wake up reborn. The second is human life – untold numbers die slumbering at the wheels of motorcars, or on unmanned ships. The third is human history. Wells's new world has no appetite for preserving the vestiges of the old, and immolates everything from buildings to coat buttons in the 'Beltane Festival', a ritual burning of the evidence of the squalid, unequal past. As the narrator (once an angry, lovelorn, and impoverished disciple of Karl Marx and Friedrich Nietzsche) describes it:

> *Then innumerable triumphs of our old, bastard, half-commercial, fine-art were presently condemned, great oil paintings, done to please the half-educated middle-class, glared for a moment and were gone. Academy marbles crumbled to useful lime [...] And books, countless books and newspapers went also into these pyres.*[7]

Wells's *In the Days of the Comet* is about the creation of a permanent today. Following the 'great change', humanity has no need of history, or even art. Were the cultural objects piled on to the bonfires once a consolation for unhappiness, or its cause? Few remember and less care now that universal love has arrived, and is here to stay. Paradise is enough. By contrast, the exhibition that borrows Wells's title is about art made, displayed and experienced in a fleeting present. We are fated to contemplate the Arundel Tomb, and with it the irrecoverable past, and the future's inevitable misapprehension of our lives. It is this that gives the contemporary moment its urgency. Larkin concludes his poem with this description of the stone figures:

> *Time has transfigured them into*
> *Untruth. The stone fidelity*
> *They hardly meant has come to be*
> *Their final blazon, and to prove*
> *Our almost-instinct almost true:*
> *What will survive of us is love.*[8]

7. H.G. Wells, *In the Days of the Comet*, 1906, 1st World Library, Fairfield, Iowa, 2006 edition, p. 281
8. Philip Larkin, 'An Arundel Tomb' (1964), *Phillip Larkin: Collected Poems*, Marvell Press / Faber & Faber, London, 2003, p. 117.

Lisa Le Feuvre Present Tense

The art of the present is too close to be judged or made sense of now; too unknown to be forced into language; too bright to do anything other than dazzle those who try to look at it. If we want to understand it, we must wait until it stops changing and living, until it eases into a position of comprehensibility and is written into history. But rushing to place it in history will only serve to make it slip through our fingers. It then becomes a legacy built on miscommunications, misreadings, new dogmas, competing views and inventions of what has gone before, constructed from untrustworthy positions, from the historical writing of previous presents. If we want to *engage* with it, we need to fall into it rather than step aside.

Every five years, the *British Art Show* attempts such an engagement with how artists are addressing the constantly shifting present. It is a 35-year-old convention that enables changes, repeats and returns to be discussed. From October 2010 to December 2011, this seventh edition of *BAS* moves through four cities, presenting the work of 39 artists. New works are introduced at each stop in Nottingham, London, Glasgow and Plymouth to create four different exhibitions, each developing from, redefining and rubbing up against its predecessor. Art is not a static entity, it is a responsive and generative practice that reverberates across the different ways in which artists attempt to understand our place in the world; this exhibition places such processes centrally by extending its definition across time as well as space.

BAS7 does not attempt to claim a new movement; that is the task of history. The moment a tendency can be described or comfortably named, the present loses its charge. Rather, it looks at art being produced today that complicates the structures that we think we know, demanding an engagement with 'now', a process that requires risky engagement with unfounded speculations. In his meditation on rhetoric, *The Flowers of Tarbes: Or, Terror in Literature* (1941), the literary critic Jean Paulhan discusses the failure of writers who attempt to break free from the conventions of language. For him, the 'terror' of literature resides in putting reinvention before paying attention to what exists; the 'terror' of art is when it is pressed into the service of a particular ideal. When art is released from an impetus to represent, it becomes freed from the weight of responsibility to be anything other than what it is. From this point, the work of art becomes an affective addition to the world. The work here does not *represent* the world, it is *of* the world. Questions, doubts, argument and speculative answers are all that this exhibition can offer, simply because in the present, that is all we have.

The art shown in *BAS7* has been made since 2005 up to the present by artists based in Britain who have significantly contributed to the ways in which art resonates through the conditions of this interval of time. To be 'significant' is to make a palpable difference, either to add a layer to what already exists, or to peel one back. To be significant is momentarily to arrest the present. Unlike other large-scale periodic exhibitions, this one claims the local rather than the well-trodden path of the international that characterises the swelling ranks of biennials, triennials, quadrennials and other intervals of return. To be based in Britain, though, and to contribute to British art, is not necessarily to be British: the vibrant and ever-developing network of connections that makes up the UK's contemporary art world has made it a place in which many international artists choose to reside, making 'British art' something that is defined both by artists born in Britain and those who live or work here.

These artists have not only shifted how art has been understood during the last five years, but have also moved into new territories within their own individual lines of questioning. Widely ranging in age, some will be presenting their work for the first time, others will be offering for consideration recent developments in established practices. The exhibition veers from figuration to abstraction, idea to object, observation to invention, recalcitrance to enthusiasm, sentiment to empiricism. It takes in painting, photography, drawing, sculpture, film, performance, sound and all the stops between, on a journey through the conflicting, contrasting and co-dependent ways of working that characterise current British art.

Embracing possibilities, impossibilities and speculations, the works in this changing exhibition address face-on the complexity of images, objects and subjectivities. *BAS7* is an oscillating extended moment that captures the present by looking at the fluctuating ideas that form it, led by each artist's critical confrontation with this complex understanding of 'today'. Gail Pickering's live-film *Sixty Six Signs of Neon* explicitly wrestles with the impossibility of such a task. A performance takes place in one location; in another, a few hundred miles away, it is observed in real time. Each of the two simultaneous presents influences the other remotely, neither capable of autonomy nor independence.

As the text in this catalogue's 'Note on the Subtitle' explains, *BAS7* takes as its 'title of the second order' *In the Days of the Comet*, from H.G. Wells's 1906 novel. Wells describes here a version of Britain set, for him, four years into the future, and for us, a century in the past. *In the Days of the Comet* is a polemical fiction proposing a utopic near future operating outside both capitalism and individualism. It is narrated by 'a grey-haired man, a figure of hale age', in the form of an unfinished manuscript. The novel presents a corrupt and

sour society, characterised by civil unrest and inequality. A story of personal, societal and international conflict unfolds as the skies fill with the green glow of an ever-nearing comet, whose light 'turned our ugly English towns into phantom cities. Everywhere local authorities discontinued street lighting – one could read small print in the glare.' While the comet's tail strikes the skies with green trails and a sharp cracking sound, a vapour falls to earth, casting all living creatures into a deep sleep. Trains travel unsupervised as their drivers slump at the controls, birds fall while in flight, unmanned printing presses continue to operate, theatrical performers drop to the floor, ships are grounded as their sailors sleep, and fires burn unchecked. Three hours later, the survivors awake, and a 'Change' comes over them all. A new spirit of generosity reigns, entrenched class divisions dissolve, lovers' disagreements subside, national borders are undone, polluting factories are closed, competition becomes meaningless, heads of state cooperate, and dogma ceases to exist.

One of his lesser-known books, *In the Days of the Comet* was written at a time when Wells was arguing with the leaders of the Fabian Society for an activist advocacy, four years before Halley's Comet was due to make its predicted 75-yearly return. The repetitive orbits of comets make them powerful figures in the imagination. Over centuries, they have endured as belief-symbols for popular superstitions, identified as harbingers of change outside human control, in spite of their inert nature. Historically, Halley's Comet has been seen as an especially powerful force, repeatedly represented in association with cataclysmic events. The Bayeux Tapestry, for example, depicts the comet in 1066 as a warning of the Norman Conquest of Britain. In 1910, as it passed almost close enough to Earth to brush it with its tail, it was photographed for the first time, inspiring speculations of doom in the press. During its most recent appearance, in 1986, the Giotto Probe provided the first visual analysis of its nucleus. Just over two decades later, it became retrospectively read as an omen warning of the damage that would be wrought by that year's deregulation of the banking system.

BAS7 uses the motif of the comet to locate artists' responses to our own uncertain and inconclusive times. Due to their looping, recurrent nature, comets are simultaneously of the past, present and future. Such time travel, under the dual influences of fantastic speculation and objective research, defines The Otolith Group's film essay *The Otolith Trilogy*, which evokes the recent past in order to ruminate on how the present constructs the future. This work claims fiction to be as reliable as fact when attempting to understand the present.

Undermining assumptions and locating ruptures, *BAS7* does not seek to entertain, educate or redeem. It offers no recipes for self-improvement, since art of the present requires

no specialist knowledge: we are all experts in the present. Far from attempting to provide a service for the receiver, this exhibition opens a contract to engage with the present, inviting those who encounter it to yield to the works' imperatives and question what is too often taken for granted. The American painter Philip Guston (1913–1980) remarked that 'the canvas is a court where the artist is prosecutor, defendant, jury and judge. Art without a trial disappears at a glance, it is too primitive or hopeful, or mere notions, or simply startling, or just another means to make life bearable.' Art is a demand to rethink assumptions and find fissures in consensus. This process sharpens attention, rather than administering palliative care, to the surrounding world. By testing and contesting, art productively makes the present more difficult and uncomfortable.

An engagement with such complexities enables us to play around with what we know, or what we once thought we knew. Failure, by definition, takes us beyond assumptions. Artists have long acknowledged the impossibility of the quest for perfection, and have embraced the open-endedness of experiment, using dissatisfaction as a means to rethink how we understand our place in the world. Through failure one has the potential to stumble on the unexpected. Varda Caivano's paintings, for example, embrace wrong turns, building structures of vision infused with doubt as to where an activity such as painting might begin or finish. Ian Kiaer, Charles Avery, Alasdair Gray and Brian Griffiths, on the other hand, offer proposals for alternative universes. Kiaer's installations draw on experiments in the histories of literature and architecture that posit alternative registers of thinking and action. He does so not to provide a fantasy of the future, but a prescription for action that responds to the particular failures of the present. Griffiths' world is like a low-rent sideshow that should have been closed for health and safety reasons. Using the sculptural grammar of scale, object, drapery and display, he collects an awkward vocabulary of objects (bear heads, corrugated iron arches) that are caressed into becoming artworks though new combinations and recategorisations.

Like Caivano, Becky Beasley uses language as a flawed means of representation, handcrafting sculptures and photographs that are pregnant with possibilities, hovering between detached minimalism and the theatre of the absurd. A key reference for Beasley is Herman Melville's short story *Bartleby, the Scrivener: A Story of Wall Street* (1853), a tale describing how withdrawal can sometimes be more effective than confrontation. Staging a passive resistance to bureaucratically required and prescribed behaviour, Bartleby responds to every question, request and order with the simple phrase 'I would prefer not to.' Nathaniel Mellors humorously investigates such conventions of behaviour and the politics of

conduct. Utilising conflicts between the will to be understood and the difficulties inherent in communication, he twists the world into contortions, rupturing consensus with nonsense.

In dismantling systems of meaning in this way, art gains the ability to unravel assumptions, redefining them as constructions rather than natural orders. A number of artists here turn to the fabulation of cultural history, redeploying the recent past and rewriting history to create the present, whether through museology, received ideas or the performance of objects and ideas. David Panos and Anja Kirschner draw on Bertolt Brecht's disillusion with Hollywood, while Spartacus Chetwynd questions the figure of the artist as an avant-garde outsider, quoting from cultural epics and events that have resonated from the past through to the future, such as Milton's *Paradise Lost* and Peter the Great's Cabin, and popular culture – *Star Wars*, Michael Jackson, *The Incredible Hulk* – as much as she does from art history. Like Chetwynd, Olivia Plender examines the construction of the myth of the artist, as well as mining fallacious accounts of history to examine ideological frameworks around the narration of history in Britain. She brings into the present moments of cultural experiment, from the television arts series *Monitor* to the *British Empire* exhibitions and the nineteenth-century Spiritualist movement, that have formulated received ideas of British national identity and the artist-genius – both false constructs that influence interpretations and behaviour.

The works here open a space for cleaving seeing from looking through a discursive set of proposals that favour ambiguity over dogma, undoing the fixities of language. Elizabeth Price constructs seductively futuristic videos and photographs from functional appliances (from sieves to soda streams, luxury cars to ships) defined by their use and associated value systems. These are combined with soundtracks of music that is just slipping into the realm of nostalgia, ripe for recuperation, and sentences stolen from philosophy and commerce that, divorced from their sources, communicate biased observations defining understanding and the application of ideas.

Similarly questioning value-associations and categorisation, Keith Wilson creates sculptures that appear as logical ordering structures but are actually nothing more than an index pointing nowhere. *Calendar*, for example, is a system for the containment of objects that has its own internal logic (a compartment for each day of the month), but its content is a systems of relations built on random juxtaposition, with no claims on either knowledge or authority. Like Price, Matthew Darbyshire and Simon Martin, Wilson observes the associations that surround objects and how their distribution and fetishisation constitute sculptural meaning – whether the art-historical tropes of minimalism and New British Sculpture, or misplaced desires for social or personal amelioration through art.

Such is the matter that creates the present at any one time – an inaccurate, unstable swirl of 'not yets' and 'perhapses'. This present, like all experiences of the 'now', is one of uncertainty and flux; between the start and the finish of this exhibition, governmental, societal, economic and cultural registers will palpably change. The only difference in *this* fact, in *this* present over any other, is that *this* one is current. What comes next is always an unknown. *British Art Show 7: In the Days of the Comet* is concerned with the production of and encounter with singularities capable of finding fault lines in taxonomies and assumptions, extending out from the particular forces that have brought the present into being and investing in how the future might be shaped. Maintaining dissensus, irresolution and doubt is essential to looking, thinking and listening. One grapples with the present, trying to understand it by clutching at the past and speculating on projected futures. Both vantage points are mired in inaccuracies, misunderstandings and partisan interpretations. It is here that an art of the present can hold an urgency and agency, without forcing itself to stand, retrogressively, as history. An art of the present can only be that which confounds assumptions today, perhaps to return comet-like in the future, elliptically and forcefully, to strip the crowns off the heads of truths and universals once again.

Charles Avery
Karla Black
Becky Beasley
Juliette Blightman
Duncan Campbell
Varda Caivano
Spartacus Chetwynd
Steven Claydon
Cullinan Richards
Matthew Darbyshire
Milena Dragicevic
Luke Fowler
Michael Fullerton
Alasdair Gray
Brian Griffiths
Roger Hiorns
Ian Kiaer
Anja Kirschner & David Panos
Sarah Lucas
Christian Marclay
Simon Martin
Nathaniel Mellors
Haroon Mirza
David Noonan
The Otolith Group
Mick Peter
Gail Pickering
Olivia Plender
Elizabeth Price
Karin Ruggaber
Edgar Schmitz
Maaike Schoorel
George Shaw
Wolfgang Tillmans
Sue Tompkins
Phoebe Unwin
Tris Vonna-Michell
Emily Wardill
Keith Wilson

Charles Avery

Since 2004, Charles Avery has been exploring the idea of an imaginary island that remains unnamed simply because its inhabitants cannot recognise its limits. Throughout Western thought, islands have operated as sites of speculation. In terms of landmass, they may be less significant than continents, yet they wield a greater power through their ability to stimulate the imagination. From H.G. Wells's isolated and diabolic experiments in *The Island of Doctor Moreau* (1896) to Aldous Huxley's mystical ideal recounted in *Island* (1962), literature is full of accounts of islands that reinvent the future and reassess the past. Avery's island is not a wish for an alternative universe; it co-exists within familiar structures of perception to ruminate on both the problems of art-making and the tools we use to attempt to understand our place in the world.

Avery's expanding island-fiction unfolds episodically in drawings, texts and objects. How or when it will conclude is impossible to know, since the artist has set it as his life's task. The beginning, though, is clear. An explorer arrives on what he believes to be an undiscovered island. His illusions are soon shattered when he is rescued from the undergrowth by a woman whom he names Miss Miss. She introduces him to the port town of Onomatopoeia, where tourists are, if not welcomed, then fully catered for. Densely populated and governed by an obscured colonial power, the town is energised by a thriving underworld. Henderson's Eggs, for example – government-approved gin-pickled eggs described by those who sample them as 'bitterly disgusting, yet ruinously addictive' – are bartered for on the vibrant black market.

The port of Onomatopoeia is depicted in the large pencil drawing *Untitled (View of the Port at Onomatopoeia)* (2009–10, pp. 28–29). Like many of Avery's drawings, the scene fades out, unfinished at the edges as the draftsman awaits more news from the island. A ship named *Utility* drops anchor in front of the Penrose Trading Company (its facade advertising Henderson's Eggs), while the docks are populated with drinking, trading and whispering – activities depicted in other drawings as the incremental description grows. Amongst the population are curious beasts, Alephs, Avatars and One-Armed Snakes, some of which can be seen writhing on the floor in *Untitled (The grass is alive)* (2007, p. 27). Each instalment of the story builds from what precedes it, and in turn influences what follows, in a rigorous and consistent framework. The eels, for example, that can be seen in the water overleaf must be there for a reason, so a feasible logic is invented: they feed off the bread dropped by the dock-dwellers.

In an effort to win the heart of Miss Miss, who seems indifferent to his love, the Explorer hatches a plan. He enters into the belief systems of the island and decides to profess himself a Hunter – an order that is both esteemed and derided locally, depending on whether the opinion is given by a Rationalist or an Empiricist – and sets out to pursue a creature known as the Noumenon. Avery uses nomenclature rooted in philosophical thought throughout the account of the island. 'Noumenon' is a term taken from the writings of Immanuel Kant referring to a 'thing-in-itself', an object that is independent from associations and assumptions, only knowable through intellect and impossible to perceive through the senses. On the island the very existence of the Noumenon is hotly debated: the creature has never been seen, yet there is an enduring conviction that it must be more than a figment of the collective imagination.

Avery's largest island sculpture to date is unveiled at *BAS7*. In *Untitled (Miss Miss finally gives in by the tree where Aeaen sought to bamboozle the One-Armed Snake by attaching himself to the tree to make himself a larger thing)* (2010), a large ornate vitrine, the Hunter and Miss Miss are at last seen engaging in an embrace. LLF

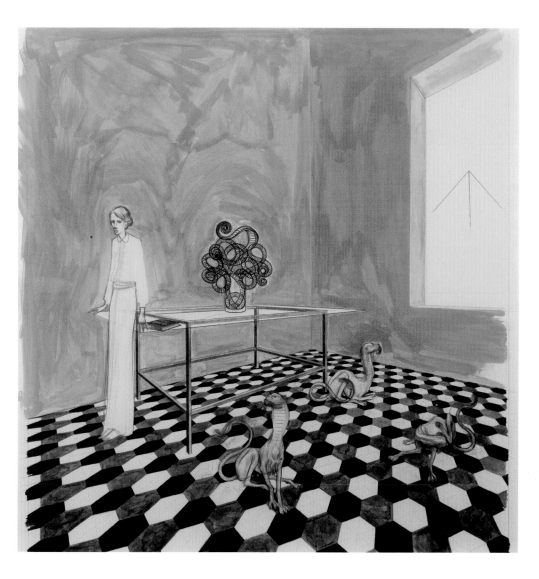

Untitled (the grass is alive) triptych, 2007 (detail)

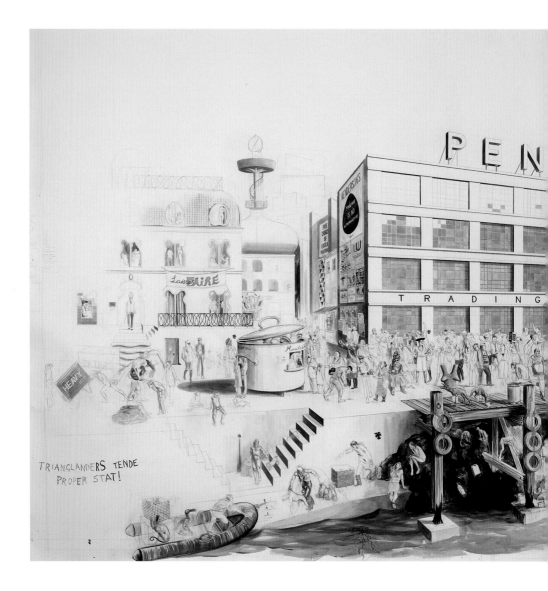

Untitled (View of the Port at Onomatopoeia), 2009–10

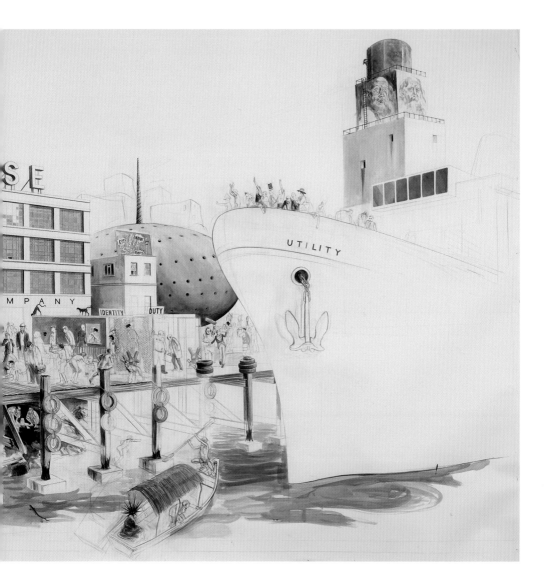

Becky Beasley

The scientist Roithamer has dedicated the last six years of his life to 'the Cone,' an edifice of mathematically exact construction that he has erected in the center of his family's estate in honor of his beloved sister. Not long after its completion, he takes his own life. As an unnamed friend pieces together – literally, from thousands of slips of papers and one troubling manuscript – the puzzle of Roithamer's breakdown, what emerges is the story of a genius ceaselessly compelled to correct and refine his perceptions until the only logical conclusion is the negation of his own soul.
Random House synopsis of Thomas Bernhard's *Korrektur*, 1975

Becky Beasley's sculptures and photographs, as mute and minimal as they appear, unexpectedly open onto literary worlds. Originating not only from fictional sources, but also from everyday objects and experiences, her works are pared-down abstractions that are based on human dimensions. A means of giving logical form to something that is not visual, the artist intends them to be at the same time 'very mental and very physical'.

For *BAS7* Beasley presents a group of seven photographs showing a single piece of iron pyrite – commonly known as Fool's Gold – enlarged from what was originally 1cm square to the size of a small stool, and viewed from seven directions (pp. 31–33). The works are named after the 1975 novel *Korrektur* (Correction) by the Austrian writer Thomas Bernhard. Each of the photograph's titles includes an orientation (Southwesterly, West Northwesterly etc) which, for Beasley, means that 'the series is never linear – it runs in a circle'. Each orientation is followed by a consecutive sentence from a single page of Bernhard's novel that refers to the building of the house and reflects the repetitive tidal motion of his writing style.

The rotational structure of the series of seven images recalls the circularity of the sixteen-pointed 'wind rose' drawn by early mapmakers to show the cardinal points from which the winds were thought to blow. In Bernhard's novel, an emblem called the 'yellow rose' found among Roithamer's papers takes on special significance. For Beasley, the sheets of pale yellow acrylic behind which each of her prints are mounted allude to the mystic and chivalric symbolism of Roithamer's yellow paper rose. They also refer to the sulphuric origins of the objects depicted. The mineral iron pyrite is an iron sulfide with the formula FeS_2. Sulphur dioxide is a dense colourless gas, which is soluble in water, and has a suffocating and unpleasant smell of burnt matches. Sulphur in its native form is a bright yellow crystalline solid. The pale yellow acrylic tones the black-and-white photographs, submerging them in a sealed atmosphere, alchemically returning to the object something of its original colour.

Beasley 'began to think about buildings as a kind of potential still-life object' after spending six months in Athens directly before the 2004 Olympics, when temporary architectural structures appeared and disappeared daily as the city prepared itself for the games. What she seeks in each sculpture that she makes is 'a potential for reconfiguration, where the object can emerge as still being somehow itself and familiar, but also as an opening onto something other'. Photography has become the means to effect this transformation of the ordinary into the uncanny.
EM

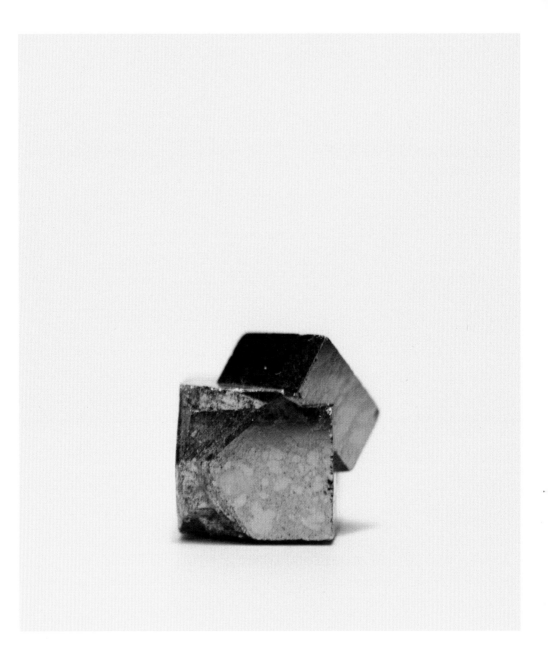

KORREKTUR (Northeasterly) (Since he's a master
of the craft and in addition drew on all sorts of books,
as I know, including the kind of books I myself got hold
of for my own purposes, for the rest of building knowledge
he needed, it was only a question of willpower and
endurance for Höller to be able to build his house.
–Thomas Bernhard*)*, 2010

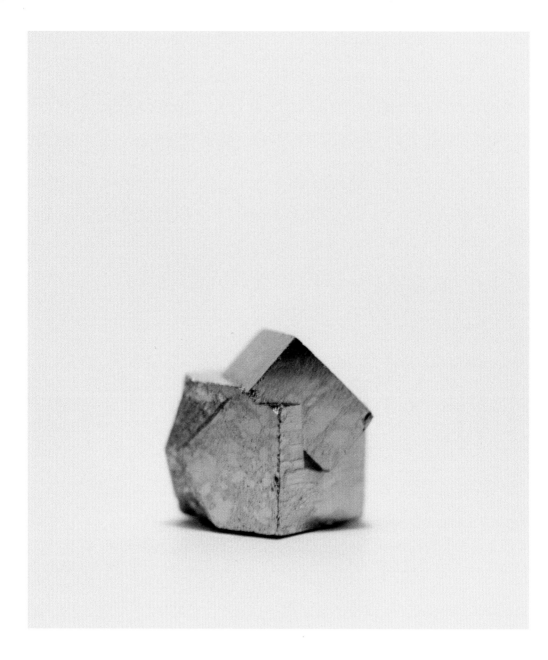

KORREKTUR (East Northeasterly) (In that case it's
quite likely, I thought, that Höller didn't see a model of
the house in a dream, but that he dreamed the house Höller.
All he had to do was trust his dream and accurately
copy the house he saw in his dream, so Roithamer.
– Thomas Bernhard*)*, 2010

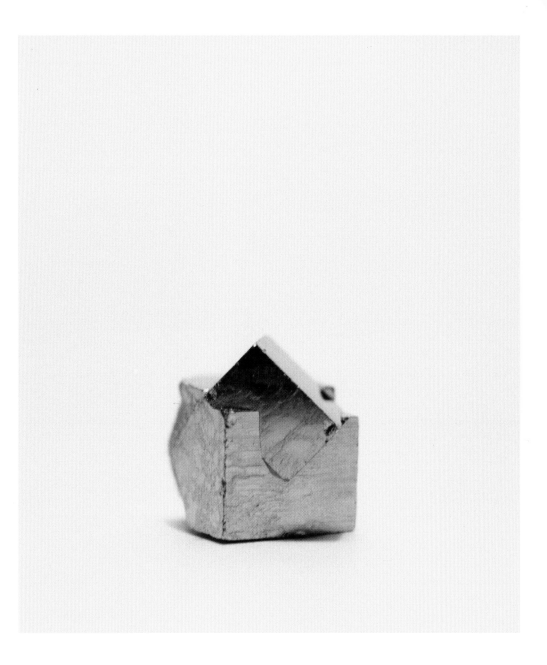

KORREKTUR (South Easterly) (Yet there's no other house to compare with it, I thought, so Roithamer. It's also possible that Höller never saw the model for his house in reality, for in reality there isn't any model for Höller's house in the vicinity, I thought, so Roithamer, it must have come to him in a dream. – Thomas Bernhard*)*, 2010

Karla Black

Direct physical engagement with large quantities of messy materials is fundamental to the sculptural interventions created by Karla Black. These cover the floor, sometimes leaving little room for the spectator to edge around, or hang from the ceiling and walls as fragile swathes of paper, cellophane and powder.

Although Black stresses the relationship of her works to modernist sculpture, they are not easily recognisable as autonomous objects. Free-standing, crumpled and bent structures made of painted paper wrapped around cardboard boxes, though fragile and abstracted, are evidently things. Twisted, dusted and suspended sections of polythene are harder to read as objects in the world, while areas of floor covered in layers of soil, dustings of cosmetics, the dried and cracked remains of liquid medications and sheets of Vaseline-smeared cellophane, utterly undermine the formal self-sufficiency of modernist sculpture, suggesting the presence of a performing body that has evaporated, leaving only its traces behind.

In their challenging of material boundaries, Black's works relate to George Bataille's notion of *informe* (formlessness), sharing the ephemerality and mutability of their materials with the sculptural abstractions of the artist Eva Hesse. Meanwhile, their expressive gestural qualities emerge from a lineage that began with the German Expressionists followed by the Abstract Expressionists, continuing through the work of the Viennese Actionists before driving such feminist artists as Carolee Schneeman and Bobby Baker. For Black, this expressive physical engagement with unformed matter prioritises 'material experience over language, as a way of learning and understanding the world'.

She emphasises her gestural, developmental relationship with her sculptures, describing it as 'a physical struggle [where] rules and techniques are intentionally not learned or adhered to; instead more haphazard, individual methods are found [allowing] my own individual unconscious desires and preferences to lead the way into making my own mistakes'. Her choice of the materials is 'something that I cannot help but use, something that comes out of desire, out of the unconscious', suggesting involuntary instinct and sensuality as prime generating drives.

At the same time, aesthetics are her prime visual focus. She thinks of her sculptural interventions as 'most importantly, compositions of form and colour'. Titles, like *Brains Are Really Everything* (2010) and *There Can Be No Arguments* (2010) – works created specifically for *BAS7* – are usually psychologically loaded. Black explains this relationship: 'Language is not part of the work. Instead, it sits alongside it in a very particular way. The titles are given to the works when they are finished, and are part of their relationship with theory and history.'

Indeed, conceptually, these works can be read in the light of Black's interest in the Austrian-born British psychoanalyst Melanie Klein, who worked with babies and pre-speech infants to analyse the meaning of a patient's relationship with the physical, material world, putting the maternal body – the first object (or 'part-object') that the infant encounters – at the centre as a figure for meaning. The 'play technique', utilising a series of simple wooden toys that she invented, allowed unconscious drives of the subject to be played out. For Black, this unconscious space – of a relationship with materials – is the place where the work begins. Formless and unstable matter combines to create forms that 'are almost objects, or only just objects, while nearly being performances, installations, or paintings'.

EM

Named and Gated, 2009

Left Right Left Right, 2009

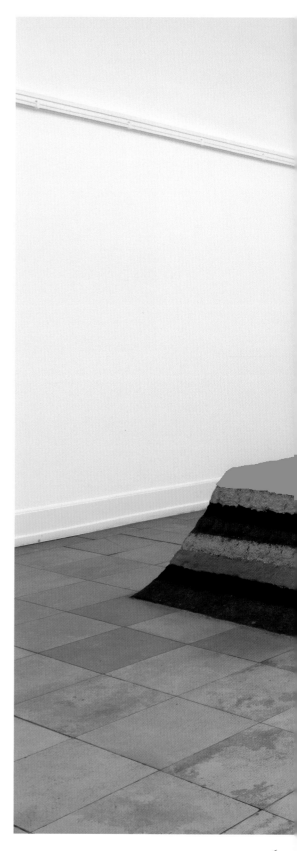

Left Right Left Right, 2010

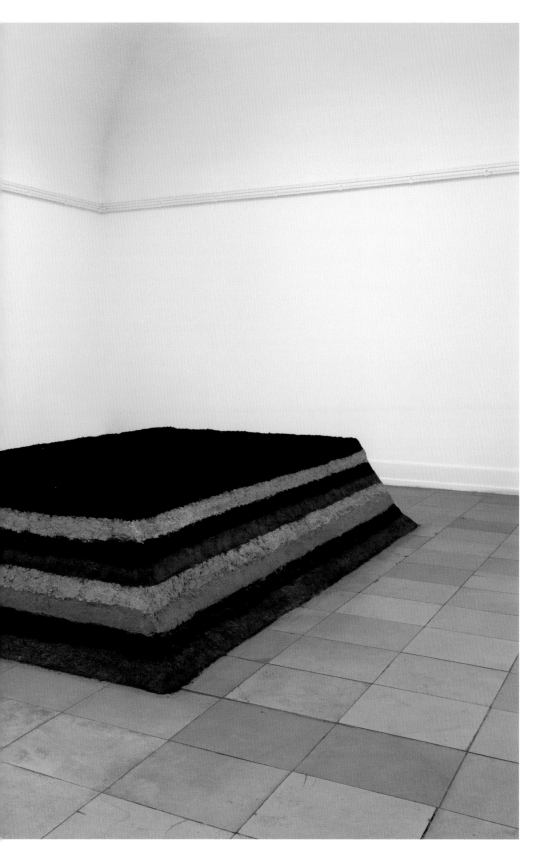

Juliette Blightman

Juliette Blightman's works extend across time and space, and are always entirely contingent on their surroundings. In her 2009 exhibition *Tomorrow Then*, an arrangement of a mirror, chair and curtain titled *Mirrors would do well to reflect more before sending back images* (p. 39), reflected the exhibition back into itself until interrupted by the gallery visitor. Each Thursday at 3pm, a screening took place, whether or not an audience was present. Blightman often occupies this mid-afternoon hour with a moment of action – for no other reason than that it feels to her the right time for something to happen. In another work, *Please water the plant and feed the fish* (2008, p. 41), consisting of a fishbowl and a plant, the artist's brother was asked to follow the instructions of the title at 3pm each day. In initiating these processes and objects Blightman describes herself as seeking to 'make looking denser'. Each of her interjections forms a transaction where the loss of time is rewarded by a wealth of invigorated perception.

A 2010 display at the Irish Museum of Modern Art (p. 40) consisted of an arrangement of potted nasturtiums grown from seeds sent by an artist friend, alongside a rug and a chair on loan from the place where she was staying whilst making the work. The objects that Blightman employs operate not only as 'things': they hold the marks of passing time and experience. This exhibition-event was accompanied by the lecture-performance *The day grew darker still*. The artist sat at a lectern in front of a single slide of a Vermeer painting projected in silence. After ten minutes, the image was switched off and the blinds rudely opened to reveal the outside world while a recording of Nico crooning her 1967 version of Jackson Browne's 'These Days' filled the theatre, the lyrics unfolding in what could easily be a description of Blightman's approach to art-making: 'These days I sit on corner stones and count the time in quarter tones to ten. Please don't confront me with my failures. I had not forgotten them.' The performance ended when, tired of waiting for something to happen, the last audience member left. The end was elastic since, with Blightman, there is no such thing as time being too long.

The writer Gertrude Stein's notion of the 'continuous present' suggests that the world – and our knowledge of it – only exists in the present moment; frames of memory are layered on to the present, making every experience unique. It is this tense that Blightman chooses to use in her work. She encourages a slowing of seeing in a process that sharpens attention, and opens up possibilities to rethink what might have been passed over.

Blightman's objects, events and interventions gently change the temperature of perception, claiming possession of an inarticulable space located just between what might or what might not happen. In *BAS7* she introduces interventions into spaces that are forgotten or deemed inconsequential. Her work begins in Nottingham with an arrangement of objects, including a vase and a painting, both placed just above a radiator, to be looked at while seated. As an admonishment to pay attention to the temporal aspects of looking the work is titled: *The formula is familiar, too quickly and too easily employed. It would not be a bad idea, in this case, as in others, to consider it from the vantage point of time, which is a convenient position when one finds oneself in the uncomfortable situation of having to judge an object so close at hand and so unusual that it tends to blind you.*

LLF

Mirrors would do well to reflect more before sending back images, 2009

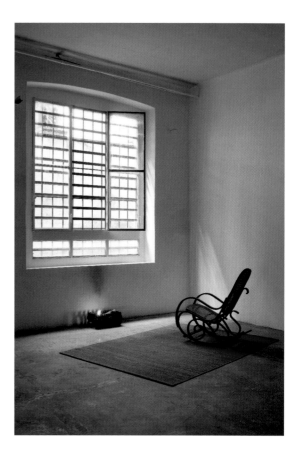

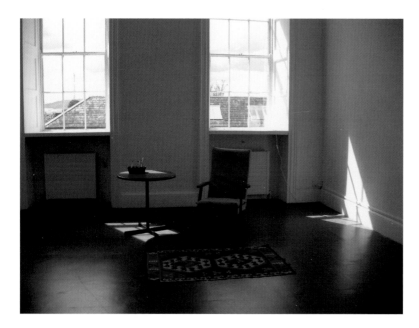

The world is not my home, 2010

The day grew darker still, 2010

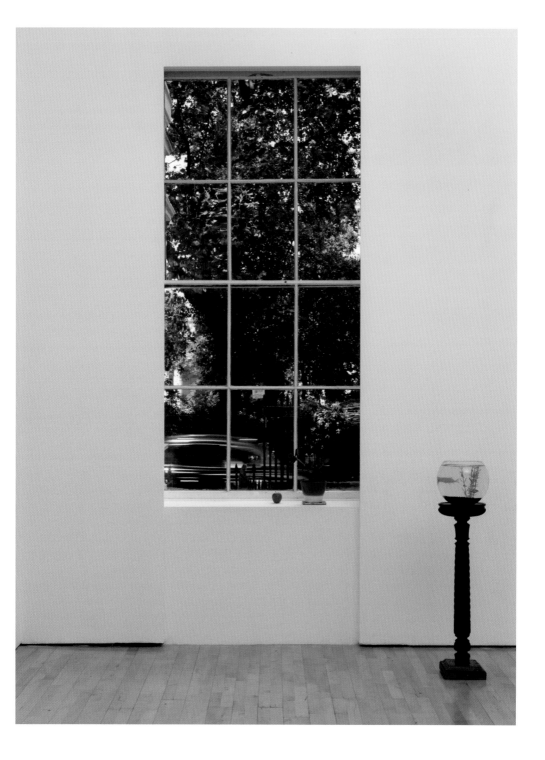

Please water the plant and feed the fish, 2008

Varda Caivano

with seepages of yellow and clusters of blue, while others are lighter, painted under bright sunlight.

The process of Caivano's paintings is inseparable from their form. Each canvas is made over a period of time as marks and ideas are built up and developed in relationship to one another. Working on a number of paintings at the same time, she treats her studio as a laboratory for thought: 'My paintings are built on layers, they are thoughts or monologues, moments that grow over time – it is as if the studio is a body or a head, a symbolic and physical place.' Using a methodology of constant research and inquiry into meaning and sensation, Caivano creates situations where the paintings develop their own voice; each conducts a journey through ideas, escaping from the artist and setting its own rules as it goes. Caivano has likened this process to improvisational music. The paintings are simultaneously composed and played, becoming complete when there is simply no more that can be done to them. She describes the moment of finishing a painting as occurring when she becomes 'locked out' from the activity and cannot go on – at this point the work is ready for an encounter with the public.

Constantly testing the juxtaposition of colour and line, Caivano embraces wrong turns, building visual structures in repeating and unfolding brushstrokes that are reworked, scratched and scraped away, even embracing ugliness when it seems necessary. Here there is no heroism; instead, it is doubt and vulnerability that fill Caivano's paintings. Her confidently tentative works hover at a moment just before collapse. In 1953, Samuel Beckett – a writer whom Caivano has researched intensively – completed a trilogy of novels with a monologue titled *The Unnamable*. Narrated by a disembodied voice, the text wrestles with the limits of language and the impossibility of reconciling thought and its expression. Caivano's always untitled paintings claim this space between inner and outer language, using acts of looking to make a bridge between the painting as object and the viewer as subject. The closing lines of Beckett's novel announce: 'You must go on/ I can't go on/I'll go on.' Persisting with an activity in spite of its inherent destiny to fail, as Caivano does, is a task suffused with optimism.
LLF

Varda Caivano's paintings are explorations into the inexhaustible possibilities of the medium. Shown in small groupings, the paintings are body-scale, demanding an intimacy that fires movement between each work. They converse and argue with each other, testing what the limits of abstraction might be and what can happen when combinations of colour, space, tone, texture and brushmarks are placed on top of each other. Caivano's work is a vertiginous play between volume and flatness, and draws on the ever-superseded histories of painting to create fields of vision communicated with the least possible means and the greatest possible effort. These works, though, refuse to be reduced to a compare-and-contrast relationship with their forebears. Some might recall the paintings of British modernists like Wyndham Lewis, others the irascible mark-making of Philip Guston, but any correlation is quickly dispelled by an undermining gesture, removal or mark. The winter paintings made in her London studio that are illustrated here use a dark palette of greens, browns and dirty pinks cut through

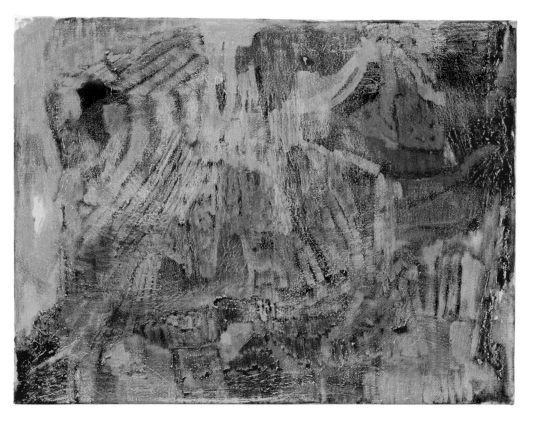

Untitled, 2009

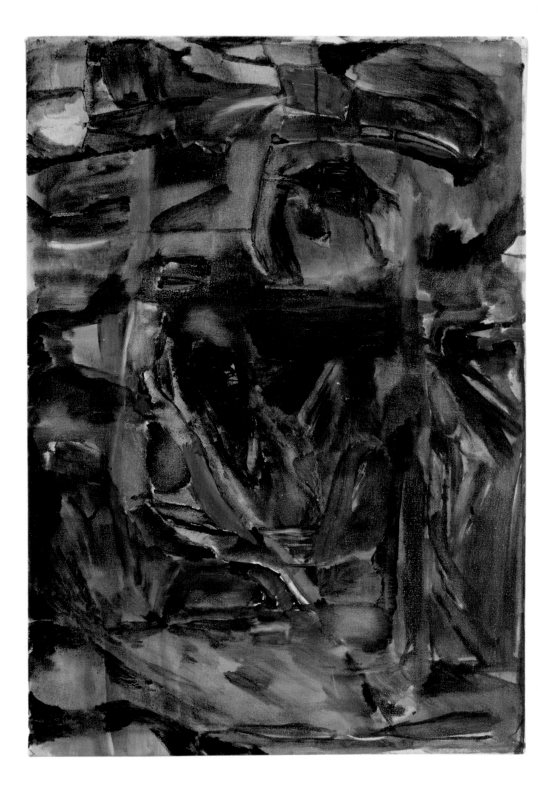

Untitled, 2010

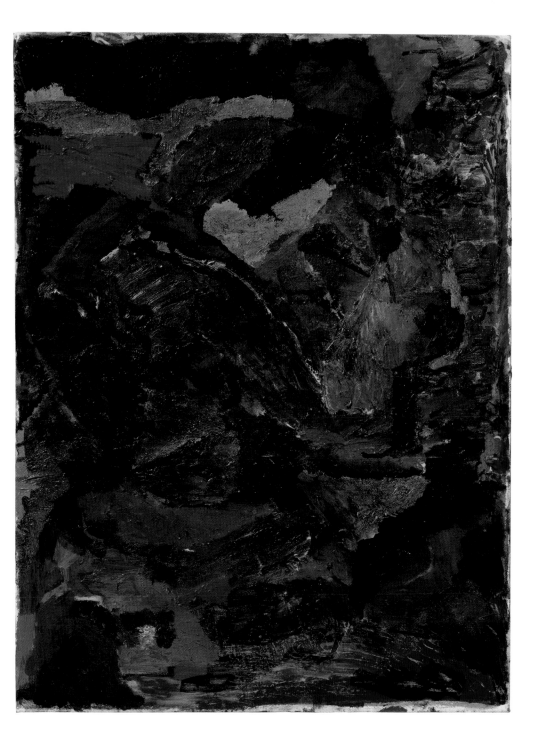

Untitled, 2010

Duncan Campbell

In Duncan Campbell's hands, history is not a search for truth; it is a quest for understanding. Accumulating fragments of reportage, he makes films that reactivate arbitrated versions of the past to examine how histories are rehearsed and mediated through contradictory and unreliable representations. In this manner he reveals the ways in which our understanding of the present is formed from a subjective history.

The film *O Joan, No…* (2006) is a study of silence. A camera hesitantly follows interruptions in darkness caused by illumination from domestic, street and theatrical lights, and the burning end of a cigarette. The soundtrack is composed of a female voice making noises but forming no words. Nothing happens, yet communication still takes place. An earlier film, *Falls Burns Malone Fiddles* (2003), made from images of 1980s Belfast gathered from community photographic archives, likewise pays attention to what happens when nothing happens. Young working-class people in an economically depressed city are depicted doing nothing other than taking positions of indifference. A faltering Scottish narrator attempts to relate a historical story, testing formal description against poetic interpretation and sociological analysis. Each fails; in frustration the storyteller lip-synchs someone else's words, but even this falls short. Here, failure and doubt communicate more loudly than description and metaphor.

Falls Burns Malone Fiddles shows how the identity of a city at a particular time is constructed through the representation of events as well as through the impact of the events themselves. Belfast is also the subject of two films, both illustrated here, that examine the construction of a public persona using reportage, drama, stock and archive footage. *Bernadette* (2008, pp. 48–49) works with the televised speeches of Bernadette Devlin, the Northern Irish activist who became the youngest elected Member of Parliament at the age of 22. Gathering British, Irish and American news footage of Devlin, Campbell shows how her individual identity is overwhelmed by competing agendas to make her representative of a 'type' – whether as an activist, a young woman, a person from Northern Ireland, a Republican or an orator – constructions that fulfil assumptions rather than reflecting her personality and beliefs.

Make it New John (2009, p. 47) tells the story of the luxury DeLorean car and the rise and demise of its charismatic maker. The American DeLorean Motor Company produced the luxury car that was featured as a time-travelling pod in the 1985 film *Back to the Future*. Locating his factory in Belfast, with the assistance of British government subsidies via the Northern Ireland Development Agency, the charismatic, cleft-chinned John DeLorean mythologised the production of a vehicle that claimed to speed the arrival of the future. Public image was crucial in the construction of the company, from DeLorean's own carefully groomed appearance to the advertising campaign's promises that this car would enable you to 'live the dream'. The reality, however, was a rather shoddy marketing fiction: the car was neither fast nor reliable, and was built on an American infatuation with cars in the middle of an oil crisis. The fiction of DeLorean falls apart as his company goes into receivership and he is stalked by scandal, and with it falters the fairytale of economic salvation for a damaged city. As Campbell demonstrates, such a baseline of disappointment comes to construct the next version of the present.

LLF

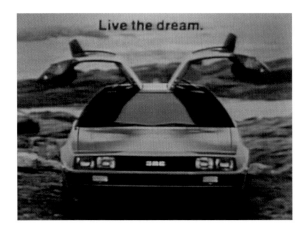

Make it New John, 2009

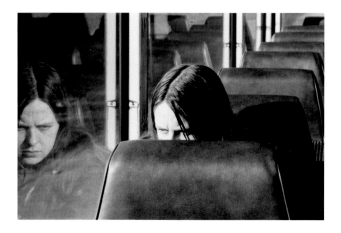

Bernadette, 2008

Spartacus Chetwynd

Over the past decade, Spartacus Chetwynd has staged a number of performances that draw on everything from *The Incredible Hulk* to Hokusai's erotic print *The Dream of the Fisherman's Wife* (1820), the *Book of Genesis* to Karl Marx's and Friedrich Engels' *The German Ideology* (1845). Equipped with jerry-built costumes and props formed from an assortment of found materials, the artist and an elastic troupe of some 20 friends and family members tell tall tales in a manner that recalls at once the theatre of Alfred Jarry, a disco at a science-fiction convention, and a primary-school nativity play. Although carefully produced, these spectacles seem always to teeter on the brink of joyful anarchy: the performers sip beer, extemporise lines and distractedly check their text messages, as though what's important here is not persuading viewers to suspend their disbelief but instead to introduce a measure of the carnivalesque into everyday life.

Independence, and its corollary self-sufficiency, is central to Chetwynd's project (her adopted moniker, Spartacus, is borrowed from the leader of an audacious slave uprising against the oppressive Roman state). For her 2005 work *The Walk to Dover* (p. 51), later documented in a 2007 film of the same name, the artist and two companions restaged a pedestrian journey from London to the coast undertaken by the impoverished title character of Charles Dickens' novel *David Copperfield* (1849), living off the land by scrumping from orchards, allotments and farmers' fields. Escaping the big city for a life of rough freedoms is a common fantasy. Actually doing so is considerably more unusual, and it is Chetwynd's willingness to scratch such itches, to pursue idle thoughts as far as they will go, that gives her work its giddy, thrilling charge. Just as her 2008 film *Hermito's Children* – in which transgender detectives investigate the case of a girl who died from too many orgasms while riding a dildo-equipped seesaw – combines such supposedly incompatible cinematic registers as murder mystery, camp melodrama and aggressive avant-garde raunch, so Chetwynd happily commingles her art and her life. She is a performance artist without a performed persona, a proponent of literalism as a method of making the imagination take flight.

For *BAS7*, Chetwynd has produced a new work, *The Folding House* (2010, pp. 52–53), which takes the form of a freestanding, inhabitable dwelling made from discarded domestic windowpanes. Resembling the De Stijl furniture designer and architect Gerrit Rietveld's 1924 Rietveld Schröder House in Utrecht (which he built in collaboration with its widowed owner, Truus Schröder-Schräder), the structure gestures towards sustainable, 'off-grid' living, and folds down neatly to allow easy transportation between exhibition venues and to further, as yet unknown territories once the show ends and the artist begins to put it to a new use. Hippie values, here, shrug off hippie aesthetics, emerging as clean and clear as glass. During *BAS7*'s run, *The Folding House* is the venue for *The Visionary Vineyard* (2010–11), a workshop led by Chetwynd that focuses on free energy. Drawing on the research of the maverick inventor Nikola Tesla, these sessions involve participants in the making of workable solar panels, and in discussions on the harnessing of non-commercial energy in art, literature and alternative communities. Foraged food is served. Chetwynd once described herself as 'trying to maintain a moment of Utopia within a twenty-minute performance'. With *The Folding House* and *The Visionary Vineyard*, the tight scripting of paradise is replaced by an attempt to ameliorate real life.

TM

The Walk to Dover, 2005

The Fall Of Man, 2006

The Folding House, 2010

Steven Claydon

I-beams made of fired clay, perverted harpsichords, a hat modelled on the cartoon dog Snoopy's racing helmet, a character from *The Smurfs*: these are some of the unlikely elements that comprise Steven Claydon's works. Presenting a parallel universe of sculpted heads, twisted taxonomies and hessian-clad domesticity, Claydon's objects, films, performances, paintings and drawings turn their attention to the construction of the cultural past, crossing time-frames to undo fixed ideas of history and set patterns of thought. 'Like H.G. Wells's *Time Machine*,' Claydon notes, 'things do not only exist in their own time – they always have potential for a future obsolescence.' His outlandish modernist-medieval hybrids remain wary of seductive nostalgia and claims on truth, operating as irritable assemblages that celebrate difficulty and dissensus.

In Claydon's universe, multiplicity is king. Refusing to accept that an idea or object can ever be simply one thing or another, he turns away from well-worn dialectical understandings of art. *The Ancient Set* (2008, p. 55), for example, looks at the misreadings of venerated models of culture that have influenced Modern European ideas. Grainy digital images show 'ancient' busts and people parading as Greeks and Romans in nylon outfits to a soundtrack that distorts a score played on replica ancient Roman instruments. Performed by a re-enactment group who meet in order to play their way back to the seat of ancient culture, this video portrays contemporary representations of Classical culture as a fancy-dress fiction built from unreliable truths and forged realities. *Atop the Loam (A Forester)* (2009, p. 57) presents a roughly hewn bust, its finger-sculpted yellow face as bright as the characters in *The Simpsons*, sitting on top of a hessian-wrapped plinth – the standard grammar of museum displays from the early 1970s that still populate cultural organisations claiming a purchase on the past. A heavy coat is shrugged across the bust's shoulders, while the distorted head stares into the middle distance, not unlike the heroic figures that fill national museums and form monuments to forgotten successes.

Amongst a group of works made for *BAS7* is *Trom Bell* (2010), manufactured at Whitechapel Bell Foundry, where Big Ben was cast in 1856. A long rope, striped like a lemur's tail, hangs down from the bell, which is installed high on the wall. Pulling this strikes a clapper made of an aluminium cast of a London brick, launching a peal that reverberates throughout the exhibition spaces. As is always the case with Claydon's works, this sculpture was developed from a spiralling set of references. Formally, *Trom Bell* is modelled on a church bell hanging outside an ecclesiastical building constructed during the 1960s wave of institutional regeneration in the East London area of Bow. Conceptually, it draws on the semi-fictitious recollections of the French writer Louis Ferdinand Céline in his novel *Guignol's Band* (1944). Using splintered prose to express a sharp anger, Céline's polemical narrative describes the East London docks during the First World War. He recounts what Claydon describes as 'a viscous vision of London, mutating, squirming, opportunistic, stinking, deadening and often surprising by turn. The novel starts with an apocalyptic scene of destruction that we are kept aware of by the constant "booming" of Big Ben and the calamitous flux in the fortunes of the unworthy protagonist.' Amongst his distorted topographical descriptions, Céline notes an area named Trom, impossibly located between China Town, Wapping and Poplar, and it is from this place that the bell takes its name. The question of fidelity constantly returns in Claydon's works, be it faithfulness, or indeed unfaithfulness, to form, history or ideas. In *Trom Bell*, Claydon uses the novelist's descriptions of the city to create a piece of 'cultural shrapnel' that has been plucked from a fictional history to find its place in the present.

LLF

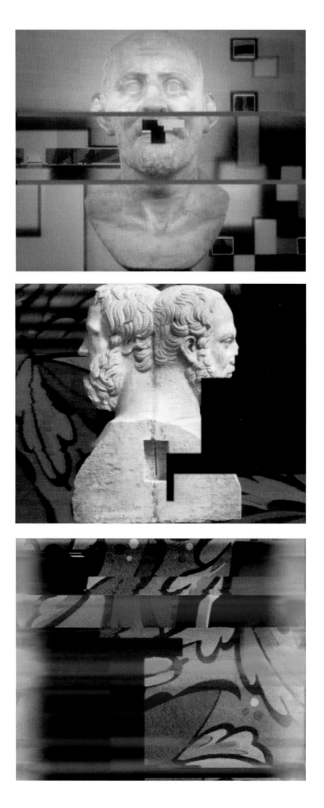

The Ancient Set, 2008

Overleaf
The Egotism of Exile, 2009 (left)
Atop the Loam (A Forester), 2009 (right)

55

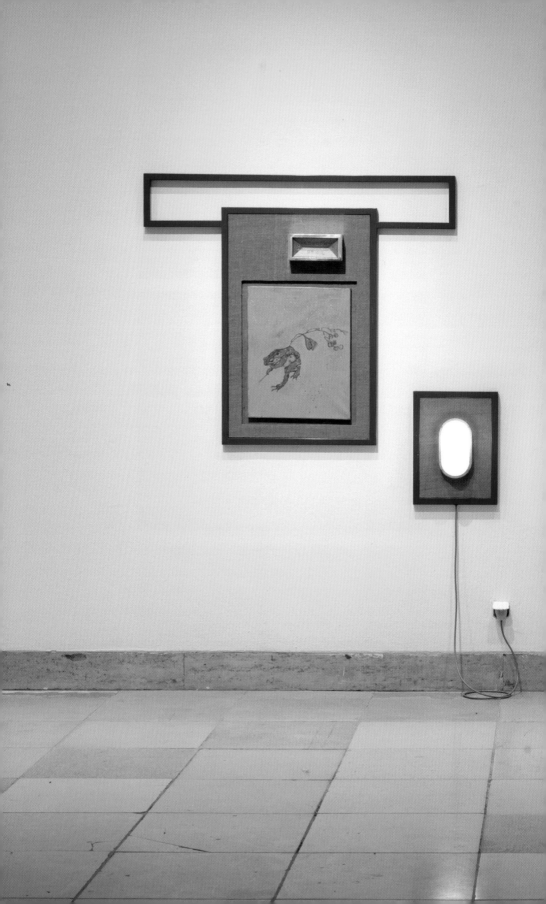

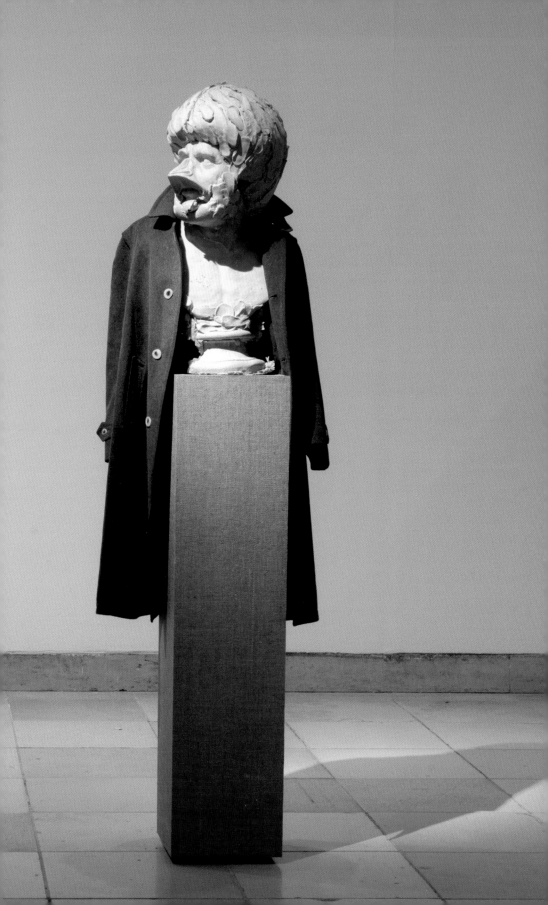

Cullinan Richards

Noting that 'the rest of the world is always there anyway', Cullinan Richards (Charlotte Cullinan and Jeanine Richards) have said that their aim is to produce 'equivalent objects in the world, rather than special objects'. Employing painting, sculpture, installation, drawing, photography, video and performance, the artists create bodies of work that, while they often turn on tall tales (not least the grand narratives of art history), also return consistently to the notion of support, whether in the physical sense of studio and exhibition furniture such as frames, table tops and lighting, or in the more nebulous sense of encouraging ideas and social scenarios to bud, flower and eventually wilt. While Cullinan Richards foreground the parts of the exhibition-making process that other artists might wish to make invisible (tools of the art technician's trade such as tape, touch-up paint and plastic sheeting feature prominently in their formal vocabulary) they are also unafraid of returning to certain motifs until they are furry with use – we might think of their continuing focus on the pneumatic go-go girls that populate the films of Russ Meyer, or images of young women on horseback performing high dives into a swimming pool, apparently a popular spectacle in 1920s Atlantic City. For the artists, revisiting and even subverting their own work is, one suspects, a way to ensure its status as 'equivalent objects'. Most things in this world have their plausibility tested more than once. Cullinan Richards test their art's plausibility to the point of destruction, and then sift through the debris in search of telling fragments.

For the first iteration of *BAS7*, Cullinan Richards will occupy the grand staircase of Nottingham Castle Museum, a building that was burned out by rioters in 1832 protesting against its owner the Duke of Newcastle's opposition to the Reform Act, and later converted into the British regions' first municipal museum in 1878. In this antechamber of the Castle's high Victorian picture galleries (a location that speaks of a now unimaginable confidence in art's authority and social efficacy) the artists stage an exploration into what it means to make, display and view painting. Alluding to the process of installation, plastic sheeting will partially cover the walls, forming a thin membrane between the usual surface of the exhibition space and the canvases on display. Among these are *Collapse into abstract (black)* (2008) and *Collapse into abstract (white)* (2010, p. 61), two heavily worked paintings that employ the image of the Atlantic City horse diver, and here articulate the vertiginous architecture of the Castle's staircase, while also revelling in their own plunging passage into blatant materiality and abstracted form. In addition to the space's usual lighting rig, Cullinan Richards have introduced their *Large Chandelier (suspended from the floor, seen from above)* (2010, p. 60), a wooden cable reel fixed with neon striplights and supported by a scaffolding frame, and several *Vertical Realism Lamps* (2010, p. 59). While these are works of art on their own terms, they also serve to illuminate other pieces in the installation, and point, with the artists' characteristic humour, to the lack of neutrality inherent in the wider politics of display (a lamp may not make us read a canvas as 'realist', but a chandelier's light adds an aristocratic penumbra to even the most proletarian of objects and images).

Elsewhere in the installation, Cullinan Richards show several works formed from newspapers placed on the floor of their studio that have received accidental splashes and drips of pigment, which the artists subsequently 'discovered' as paintings and have re-presented as glassine prints (p. 60). Not quite authored (the specific news stories on each sheet were of course incidental to the fact that it was used to protect the studio's flooring, while each paint mark was pure chance), these pieces underline the artists' continuing interest in the inescapable contingency of all things. The connection between art and the news agenda is not forced, but simply revealed to be there all along, hiding in plain sight.
TM

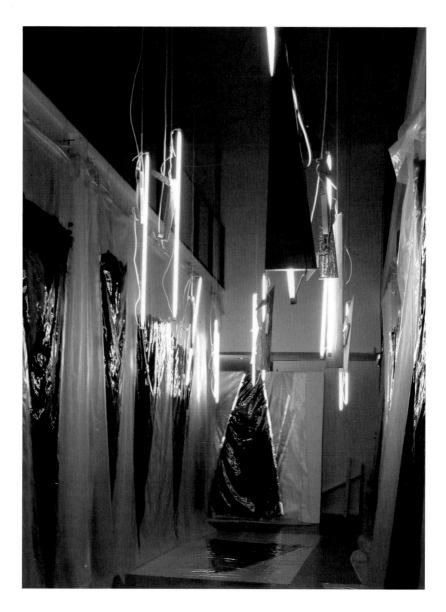

Vertical Realism Lamps, 2010

Twenty rolls of tape, 2010

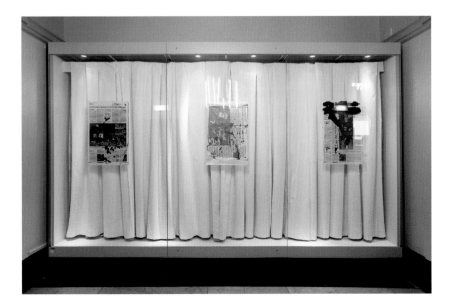

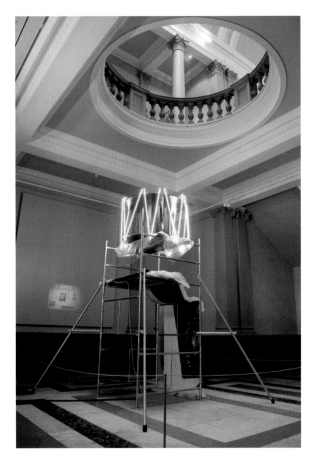

Top
Cabinet containing: *The Breakdown*, 2010;
*Creative Sterility traps England in a wasteland
of ambition*, 2010; *Diego Maradona for offensive
comments and gestures*, 2010

Right
*Large Chandelier (suspended from the floor,
seen from above)*, 2010

Opposite
Collapse into abstract (white), 2010

Matthew Darbyshire

Matthew Darbyshire's work addresses the design and look of the 'experience economy' that characterises contemporary times. Arts centres, estate agents, mobile-phone companies, civic buildings, fast-food outlets, banks and housing developments indiscriminately signpost themselves with upbeat welcomes, pointing to better futures, fully accessible to all. Whether in the sphere of culture, health or retail, in the experience economy 'unique' events for 'service-users' promise to enhance and transform lives. Shopping is no longer just about buying things, it is a 'retail experience'. Culture is no longer about engaging with art, it is a 'fun day out for the family'.

Such bland consensual directives are the target of Darbyshire's attention. *Blades House* (2008, p. 63) transposed the footprint of a nearby ex-Local Authority apartment to Gasworks, a gallery located in a South London area in the midst of regeneration, to create an entirely plausible bachelor pad for a young creative. Bright colours and clean lines define carefully selected furniture and objects redolent of off-the-peg promises of exclusivity. *Funhouse* (2009, p. 63) turned the Project Space of the Hayward Gallery into a zone for interactive decision-making, but in a caustic move away from endless misplaced calls for participation in art, no part of the installation could be touched. In *ELIS* (2010, pp. 64–65) the artist wrapped the East London gallery Herald Street in a 50-foot hoarding announcing 'an exciting urban lifestyle' that would embody 'respect', 'vibrancy' and 'tranquillity', offering a 'unique opportunity' to be part of a 'cutting edge sanctuary for the senses'. Located close to the part of the capital hosting the next Olympic Games, *ELIS* refers through its title to the area in ancient Greece that was the site of the first Olympic festival. Amid the local conditions of poor housing stock, daytime drinking and making do, Darbyshire appropriated the promises of 'student developments' and 'lifestyle accommodation' seen on hoardings around building sites the length and breadth of Britain.

In *BAS7*, Darbyshire continues his research into taste and display with *An Exhibition for Modern Living* (2010), its title derived from a 1949 exhibition at the Detroit Institute of Arts that set out to demonstrate 'modern taste'. The display of objects constructed an idea of an aspirational lifestyle, with the curator Alexander Girard claiming that the selected objects 'all share a common, unconscious pride in developing new values rather than depending only on the thought and effort of the past'. Riffing off that exhibition's hall of objects, Darbyshire has created a display system reflecting 'today's ubiquitous home, retail and museum preference for the chunky Judd-esque floating wall shelf that has been ripped off and adapted by pretty much everyone'. Into this armature are placed an inventory of items borrowed from manufacturers or purchased from home stores in the lead-up to the opening of *BAS7*. These are categorised around a slightly perverted version of the index used by *The Exhibition For Modern Living*, with Darbyshire adding to its medium-based categorisations such as glass, china, pottery and wood, 'more personal and obscure sub-categories like nationalistic, cool white, gold or ethnic'. These tastes are as High Street as they are exclusive high-end designer, ranging from a unisex gold windbreaker from American Apparel to bulldog bookends from Dwell, cutlery from Alessi and Union Jack cushions from Jan Constantine and John Lewis.

Such is the power of designer lifestyle desire that there is no longer an outside. Even tongue-in-cheek choices are cliché-ridden and already inscribed within marketing campaigns. Kitsch is no alternative, vintage offers no exclusivity, minimalism is not an anti-consumerist gesture, designer items are simply more of the same, and art can be neatly neutered into a non-specific upbeat style of representing the present. By adding no more material to the world other than a call for critical reflection, Darbyshire steps away from the demand for an artist to be a service providing education, regeneration, redemption and entertainment. His works turn shop-bought domestic comfort into fertile seeds of doubt and discontent, suggesting that dissensus might be more productive than consensus.

LLF

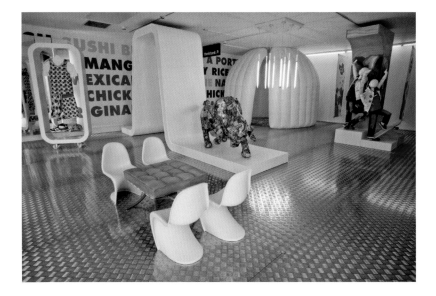

Blades House, 2008

Funhouse, 2009

Overleaf
ELIS, 2010

63

Milena Dragicevic

The *Supplicants* are substitutes for both a person and a photographic representation. Their twisted sculptural heads have been built out of photographs of friends and acquaintances that are then stretched and grown into futuristic models for new human forms. The faces have been dissected and interfered with through sutures and additions, offering a series of openings. Dragicevic warns that 'these are not psychological portraits of the sitters (in fact I would not even call them portraits), yet there is always a desire to see them as such – to want to get to that 'thing' inside, but there is no 'thing'. The paintings remain unknowable even to me. After I finish them I wonder how I even got there in the first place.'

Dragicevic's works explore the formal properties of portraiture, architecture, sculpture and language, often drawing on biographical information to bring about the intersection of unexpected references. She was born in Knin, Yugoslavia, a Serbian enclave. Following the post-war reconfiguring of borders, Yugoslavia ceased to exist and Knin became part of Croatia. As a result, Dragicevic's passport states her birthplace as Croatia – a fictional point of origin, since she was born in Yugoslavia and is Serbian. This notion of an unreachable place that is both fictive and real informs her approach to painting: objects and subjects are frequently doubled, reversed and mirrored.

Later, Dragicevic immigrated to Canada. On arriving in the unfamiliar country, she found similarities between the visual appearance of the Inuit language and that of her own native tongue. She has used Inuit to title works (for example, *Tuksiarvik* (2007), meaning 'prayer-place'); these titles are left untranslated to draw on the power of a language that can never be known in its entirety, a quality that she seeks to maintain in her paintings. In *Supplicant 77* (p. 68), the mouth of the figure is replaced with what appears to be a post-box slot – a form that has been borrowed from Native American imagery. In another series, *Erections For Transatlantica* (begun in 2009), unnamed assemblages that twin obsolete industrial machines with misplaced epic public sculpture unfold within solid coloured spaces split in two, the title alluding to a cross–Atlantic function that is never clarified further.

A figure stretches out her hands in a pleading gesture, her face mutated into a mask that seems both animalistic and protective. Another is turned upside down, his nose elongated and head tipped back as if the weight of the appendage is too much to bear. These are portraits in Milena Dragicevic's ongoing *Supplicant* series, begun in 2006. Each is numbered positively and negatively, but not completed in numerical order – for example, number 77 follows minus 13. A supplicant is a stand in – one who petitions for another in acts of activism or religious humility. To be a supplicant is to devote oneself to another, yet it is also to ask for charity. The hands in *Supplicant -13* (p. 67) might be illustrative of either selflessness or self-survival, extremes that run throughout Dragicevic's practice.

In spite of their precision, Dragicevic's paintings are always both one thing and the other: painting and sculpture, figurative and abstract, always defiantly refusing to settle down into either a subject or object position.

LLF

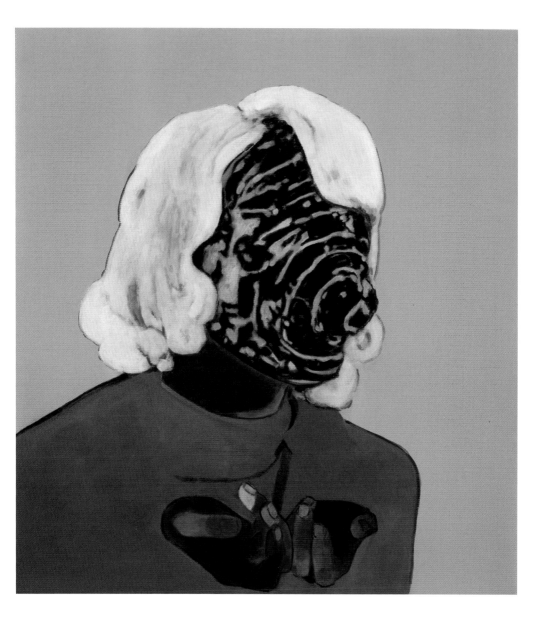

Supplicant -13, 2008

Above
Supplicant 77, 2008

Right
Supplicant 309, 2009

Luke Fowler

Luke Fowler's films are documentaries in as much as they present information, but they make no claims to objectivity. His work is a meditation on the coexistence of incompatible truths and the relation between the individual and society. In *What You See is What You Get* (2001), for example, the Glaswegian psychiatrist and writer R.D. Laing's controversial experimental community at Kingsley Hall for people in varied states of psychological distress is studied through a collision of photographs, notes, media coverage and recordings of therapy sessions. Opposing views are shown side by side. As a young Melvin Bragg notes in one segment of archival footage, Laing's experiment was either lauded or dismissed. Fowler's study combines layers of meaning to question the possibility of definitive truth.

Many of Fowler's films are collaborations with experimental musicians, transposing onto one another the structural forms of moving image and sound. The filmmaker Hollis Frampton, an artist of great interest to Fowler, described in 1968 how 'The camera reads from a score that is both the notation and the substance of the piece. It can and does repeat the performance, endlessly, with utter exactitude.' *Composition for Flutter Screen* (2008, pp. 72–73), made with Toshiya Tsunoda, a composer who works with field recordings that seek to capture the sounds of objects, is both a musical and film score. Fragments of film, showing images such as the surface tension on water in a glass and a moth caught in the hand, are projected on to a handmade screen of silk that trembles as an electric fan constantly moves its surface. Intermittent bright light and amplified sound interrupt the choreographed flow of the work, revealing the apparatus and undoing any possibility of illusion – a strategy firmly established in the histories of experimental filmmaking that Fowler departs from.

The 16mm film *A Grammar for Listening (parts 1–3)* (2010, p. 71) investigates the relationship between location sound and its filmed representation, pointing to the dissonance between visual and aural perception. Each episode is a collaboration with a field-recording artist who creates the soundtrack, while the projection shows the sites in which the sounds have been recorded. In Part 1, Fowler works with his frequent collaborator Lee Patterson, who captures sounds such as the crackling of burning walnuts, recordings of underwater life, or the click of a spring in a lighter. In Part 2 sound artist Eric La Casa isolates aural fragments, such as the movement of elevators and traffic noise, to map urban environments. In Part 1 the visual element moves between distanced landscape and abstract close-ups of the sites where the recordings took place; in Part 2 the sound-locations are punctuated by blocks of colour. Fowler works with Tsunoda again in Part 3; here, sonic and oracular perceptual fields are brought closer, with Tsunoda shown recording the literal sounds of thinking, using a stethoscope with built-in microphones attached to his and a collaborator's temples while sitting in various locations around London's Hyde Park. Although sound and image are synched, in all three parts the distinctions between seeing and listening are amplified.

A Grammar For Listening examines alternative ways of listening and understanding sound, and mines the assumptions that construct our understanding of the present. By using found footage, archive material, filmed observations and music, Fowler pushes to the limits of his films' representational capabilities. Similarly, by creating portraits of marginal individuals who confound hegemonic order, from the composer Cornelius Cardew (*Pilgrimage From Scattered Points*, 2006), to the musician Xentos 'Fray Bentos' Jones (*The Way Out*, 2001), he seeks out alternative models of being in the world. Rather than romanticising these self-imposed exiles Fowler lays their failings and inconsistencies bare, and looks to the value and complications of being on the outside.
LLF

A Grammar for Listening (parts 1–3), 2009

Composition for Flutter Screen, 2008 (with Toshiya Tsunoda)

Michael Fullerton

Michael Fullerton's subject is the aesthetics of persuasion that has brought certain figures from industry and history into contemporary public consciousness. His paintings, screenprints, texts and sculptures focus on individuals and multinational organisations that have influenced, and been influenced by, the production and consumption of knowledge, from Leon Trotsky to Sir Joshua Reynolds via DJ John Peel, the chemical company BASF, Columbia Pictures and the Vidal Sassoon Corporation.

Seminal Event Repeated (2007, p. 75) shows Vidal Sassoon, barefoot in blue jeans with hands on hips. The silkscreen *Seminal Event (Vidal Sassoon Corp. Executive Board 1968)* (2007) repeats three times, high on the gallery wall, an image of a group of businessmen in discussion. Their sideburns, suits and papers indicate a very different corporate environment from that of today. Sassoon has long fascinated Fullerton as a corporate identity channelled through an individual. 'The company has such a strong brand image that really effectively brings together "style" and "modernity", he has said. 'This to me references all the ideals of the early modernist avant-garde.' The meeting depicted in the silkscreen took place the year Sassoon cut Mia Farrow's hair for the film *Rosemary's Baby*; a low-maintenance style that launched him as a celebrity hairdresser and became emblematic of an era where values radically shifted. The triptych changes with each repetition from black to gold, turning the image from a descriptive communicator of facts to one concerned with aesthetics. Fullerton asks: 'How do we decide that something is beautiful? I liked the idea of a bunch of guys sitting round a table pondering these issues within a corporate environment.'

In *BAS7* Fullerton exhibits a selection of oil on linen paintings, taking the form of eighteenth-century portraits, alongside silkscreens on newsprint. Portraits implicitly track hierarchies of class and values; Fullerton mines such traditions by synthesising subjects and time frames to underline the unreliable truths of representation.

The paintings *Catherine Graham* (p. 77) and *Tatiana Romanov* (both 2008) demonstrate his 'interest in the triangular relationship between the person represented, the painting and the viewer. By analogy, this reflects how information is mediated and the political power shifts involved.' Katherine Graham was the first female media magnate and within the pages of her publications, which included the *Washington Post* and *Newsweek*, she defended the media against party-political influence. Tatiana Romanov was the youngest daughter of Tsar Nicholas II, the last sovereign of Imperial Russia. Many rumours circulate as to whether she survived the Bolshevik Revolution or not, with claims of her existence recurring in tabloid media features. By looking at the invention and representation of public figures, Fullerton investigates the knotted relationship between aesthetics and history, which is mediated both by the desire for power and idealised views of the past.

In his 2008 *Colour study of the painting 'Elizabeth Foster' (1787) by Sir Joshua Reynolds (Leon Trotsky version)* (p. 76) the artist uses the colours of Reynolds' painting of Lady Elizabeth Foster, Duchess of Devonshire. His guide is a reproduction in a book where the painting is wrongly attributed to Thomas Gainsborough. Such portraits always mask the private complexities of each person's life and relationship to power structures: Reynolds shows his sitter, whose private life was something of a scandal, as demure, slightly smiling. His palette is used to depict a smiling, avuncular Leon Trotsky, his face taken from a Bolshevik poster. Fullerton explains: 'Whenever I start a painting I can never decide what colour scheme to use, so I end up modelling my paintings on other peoples' colour schemes. There are three different paintings I always seem to go back to – *Elisabeth Foster* by Reynolds is one. The idea is to filter an image through someone else's colour scheme, looking at colour as a system, and to see if the aesthetic values overpower the political references or vice versa.' It was Reynolds' mastery of painting that gave him access to an otherwise inaccessible powerful social elite. In this sense his image is as propagandistic as Trotsky's posters.

LLF

Seminal Event Repeated, 2007

Colour study of the painting 'Elizabeth Foster (1787) by Sir Joshua Reynolds (Leon Trotsky version), 2008

Catherine Graham, 2008

Alasdair Gray

Alasdair Gray's murals, drawings, paintings, posters, plays and novels are inextricably intertwined with his own life, charged with evocations of alternative universes. As a child growing up in Glasgow, he drew incessantly, inventing imaginary worlds to compensate for dull routine. Surrounded by books, he was fascinated by those illustrated by their own authors and decided at a young age that he could do just as well himself. Amongst his eighteen published books, the best known is *Lanark*. Begun in 1952 when Gray was a student and finished in 1978, it has been hailed as a landmark of twentieth-century fiction. Illustrated by the author, this tale in four non-consecutive parts veers in and out of biography in a time-travelling account of two individuals, Lanark and Duncan Thaw, who each attempt to depict a disintegrating city, Glasgow and Unthank, in words and pictures respectively.

Gray's works in art and literature take interwoven paths, overlapping in form and content, often completed over many decades. Several of the works selected for *BAS7* were begun in one decade, finished in another. In *Lanark*, Duncan Thaw is described trying, and failing, to portray his city in a mural, a task that is never finished since he can never be satisfied by his attempts. The same is true for Gray. For ten years, he has been working on a mural for Òran Mór, an arts centre in Glasgow. Portraits, landscapes and symbols curl their way through the building, while the auditorium ceiling is a heaven of stars, galaxies and clouds. This enormous task has no planned end point and, like Duncan Thaw's fictional murals, is under constant revision. One of the works in *BAS7*, *Blue Denim Christine and Dan Healey, Rex Scortorum* (2008), depicts a naked, crowned Dan Healey, the man who made the introduction that led to this commission.

Often Gray will turn a drawing into a painting several years after its completion, using what he terms 'heraldic colours', to capture moments from memory rather than from direct study. The drawing *Andrew Gray Aged 7 and Inge's Patchwork Quilt* (2009, pp. 80–81), for example, shows the artist's son lying on a quilt made by Gray's first wife. The child's eyes stare out from a sea of different patterns; a legend notes 'drawn 1972, painted 2009'.

In his earliest portraits Gray used black or grey backgrounds and subdued tones, avoiding bright colours for fear they would distract from his fine lines. In recent years he has begun to add bold colour to his drawings. Also included in *BAS7* are two drawings from the *May Hooper* series, begun in the mid-1980s. Drawn on brown paper, chosen for its cheapness and easy availability, these are made with a thick-nibbed fountain pen 'whose outline varied with the angle of the stroke, which was enough to suggest the volume of bare limbs etcetera without any of the hatching I kept for her garments.' Hooper, a life model and neighbour, is seen here in two works: *May in Black Dress on Armchair* (p. 79) and *May on Invisible Armchair* (both 2010). Both have bright blue backgrounds, the former showing the subject seated, arms folded and wearing winter clothes, the latter a nude portrait of Hooper stretched out in the same chair. These, again, have been made over an extended period of time, the bright colour added later. Gray's work is a continuous process that spans decades, but has paid scant regard to tendencies elsewhere in art over the years.

In the postscript to his 2010 book *A Life in Pictures*, Gray muses: 'it's queer being 75. Like Wyndham Lewis (an artist who also preferred distinct shapes) I disapprove of Time. When working fully, productively and without interruption we live in a continual present, not as ecstatic as the present enjoyed by active lovers, but calmer and longer lasting, until need of food or rest stops us. That is why anyone enjoying a very big job finds it hard to stop. Arshile Gorky said, "I never finish a painting. I just stop working on it for a while." Often we continue work begun by others.'

LLF

May in Black Dress on Armchair, 2010

Andrew Gray Aged 7 and Inge's Patchwork Quilt, 2009

Brian Griffiths

Curiosity – in both its noun and verb forms – snakes through Brian Griffiths' sculptural practice. Just as seventeenth-century gentlemen scientists assembled 'Cabinets of Curiosities' brimming with bizarre holdings of dubious authenticity, so in the artist's work we encounter a smudging of the line between empirical knowledge and entertainment, and found objects that have been transformed into vehicles of imaginative escape, including the control panel of a starship (*Osaka*, 2004), a vast galleon (*Beneath the Stride of Giants*, 2005) and what appears to be the salvaged remains of Robinson Crusoe's slave ship, washed up on a tropical island (the group of works that made up his 2005 exhibition *The Man Who Loved Islands* at Arnolfini, Bristol). But while Griffiths manipulates his junk-shop materials into new forms, and new spheres of meaning, stubborn traces of their past lives remain – a doormat, here, never quite shucks off being a doormat, and a closet always eventually outs itself. Like the TV sitcom character Rigsby in *Rising Damp* (1974–78) – an abiding influence on the artist's work – they cannot escape what they are, and their attempts to do so only magnify their flaws and their frustrations.

In *Life is a Laugh* (2007, pp. 84–85), a 70-metre-long work commissioned by Transport for London for a disused platform at Gloucester Road Tube station, Griffiths explored the familiar human experience of waiting. Envisaging the platform as a dusty mantelpiece or trophy cabinet that denies the viewer the opportunity to see an object in the round, he created a sense of dynamic sculptural space by building an ocular 'obstacle course' in the manner of 1980s British game shows *The Krypton Factor* and *We Are the Champions*. Here, viewers' curious eyes were encouraged to travel along ramps, through hoops, up ladders, and past dirty mattresses, oil drums and the 7.5-metre-tall disembodied head of a panda. Looking at this beast's black-and-white face (something Griffiths has described as both 'a Croydon Jeff Koons' and 'like a drawing of itself'), odd thoughts begin to occur: does the plane of the platform conceal a giant, black and white body, like the earth that covers the torso of Winnie in Samuel Beckett's play *Happy Days* (1961), a character whose existence is measured out, in an echo of the temporal regimentation of the life of an office worker, by 'the bell for waking and the bell for sleep'? Is its disembodiment indicative of a sublimated or abandoned libido (pandas are, after all, notoriously indifferent to sex), and if so, what does this say about the tension between personal desire and public space? Is life, when you are waiting for a train amidst the farts and burger fumes of your fellow commuters, really such a laugh? Griffiths' answer, one suspects, would be a complex and qualified 'yes'.

For *BAS7*, Griffiths presents two works, the first of which – the large canvas teddy bear's head *The Body and Ground (or Your Lovely Smile)* (2010, p. 83) – will be shown in Nottingham, to be joined later in the exhibition's tour by a body stitched from the same sagging, half-defeated fabric. Supported by ropes, the bear's head suggests a tent and theatre backdrop, a place of refuge and a moment of artifice. Decorated with embroidered patches bearing the names of various destinations (Ohio, Paris, Innsbruck), it feels as though it belongs to an old-fashioned travelling carnival, ready to be rolled up and shipped onwards the moment it has worked its tatty magic. The carnival's charms, though, depend upon our not peering too closely lest we see how an illusion is achieved. Griffiths' work invites us to do the opposite: stare human life in the face (with its historical baggage, its hopeless hopes, its heartbreaking self-delusions) until we can't help but smile.

TM

To the Wonder and Satisfaction of All People, 2005

The Body and Ground (Or Your Lovely Smile), 2010

Life is a Laugh, 2007

Roger Hiorns

Roger Hiorns investigates the alchemical transformation of ideas, actions and materials. Pliable organic or naturally occurring matter – brains, fire, crystals, sperm, drugs – is introduced into fixed man-made structures like engines, architecture and street furniture, setting up tensions between objects and experiences, corrupting symbols and systems of control.

Hiorns' works tend to be self-contained, stepping aside from any external narrative and setting in motion processes that take place outside of his control. In *Seizure* (2008), for example, 75,000 litres of the chemical compound copper sulphate were pumped into an empty bedsit in a London social housing block. This formed breeding crystals that took hold of the building, their sparkling blue hue created from minute amounts of energy. Crystallographers define the characteristic shape taken by crystals as their 'habit' – a term that refers to a repetitive, unconscious behavioural pattern that nevertheless moves towards a system of order, controlling unknown, disordered experience. Hiorns plays with this idea of control and the lack of it: the works self-produce, expanding and growing as they are released into the unpredictable public realm.

Hiorns frequently uses invisible processes to initiate palpable interruptions. In an untitled work from 2007 he smeared spotlights illuminating the Acropolis with semen, invisibly altering a symbol while alluding to the myth of Athena. In *L'heure bleue* (2002) and *Joy* (2003), ostentatious scents stain aggressively minimalist sculptural forms, the names of the fragrances disingenuously suggesting that a waft of chemical concoction might change atmosphere and mood. *Untitled (Alliance)* (2010, p. 87) consists of two engines from long-range surveillance planes sourced from the United States Air Force – machines used by one nation to assert control over another. Ground down Effexor, Citalopram and Mannitol, prescription drugs used to control unwanted emotions such as trauma and depression, are incorporated into the inner workings of the engines. These visible and invisible tools of manipulation transform and undo one another to produce a speculative aesthetic form that indifferently parades the possibilities of power.

Speculation involves an entry into what cannot be known, a process that invokes doubt and its counterpart, belief. *Untitled* (2005–10, pp. 88–89), consists of a burning flame that sits on top of a generic municipal park bench. Like all flames, it needs to be tended: at unspecified times a naked young man sits beside the fire to keep it burning; in his absence, the gallery hosting the work cultivates the flame. Hiorns has worked with fire before: in *Vauxhall* (2003) a metal gully in the Sculpture Court at Tate Britain breathed fire rather than dispersed water as one might expect. Both works are votives, perhaps, evoking human faith.

Repetitive and ritualistic, all of Hiorns' works involve a transformation of one thing into another. In spite of their alchemical and aesthetic qualities, however, his works are not spectacles – the crystals simply grow blue because of the nature of the material; the young man is merely there to do a job. But it is within the uncomfortable relationship between doubt and belief in our contemporary present that Hiorns' sculptures operate, disrupting what we think we know about power.

LLF

Untitled, 2008

Untitled (Alliance), 2010

Overleaf
Untitled, 2005–10

Ian Kiaer

Buildings formed of card, wood and silver foil sit on islands and waves of foam against mountains of paper files. A collection of triangles lies on the floor as if waiting to be picked up and constructed into a solid structure. A black rubber rectangle high on the wall reflects sunlight and becomes a painting rather than a block of material. A painting retreats into a corner, and a plastic container curves itself into a sculpture that one might fall over while stepping back to wonder why the painting has been hung in such a strange position. These are some of the weightless, worthless objects that Ian Kiaer uses to form his installations that, with an economy of means, mine the history of speculative thought to perform an aesthetic magic.

Endnote, pink (black) (2010, pp. 92–93), conceived for the Munich Kunstverein, drew on the grammar of the still life and the syntax of the readymade, feeding off the museum's nineteenth-century painting collections. Utilising shifts in scale and sightlines, painting-like objects were placed in unlikely locations, butting up against a doorway or positioned so high as to almost touch the ceiling. Yellow latex, silver foil and fabric were stretched as paintings, some with abstract lines added, others left as found. Sheets of rubber and plastic hugged the floor alongside a towering inflated transparent plastic bag and a series of modular triangles (p. 91), reminiscent of Bruno Taut's 1914 Glass Pavilion – a recurring reference in Kiaer's installations. Championed by the German writer Paul Scheerbart in his 1914 manifesto *Glass Architecture*, Taut believed buildings made of glass could move towards creating an earthly paradise.

Referring to such experiments in the histories of literature, architecture and thought, Kiaer creates proposals for rethinking how the world is structured and understood. Narratives of resistance and disappointment form the conceptual base for his installations, and he frequently turns his attention to figures who have been exiled as a result of their public dissidence (for example, the poet Irina Ratushinskaya who was imprisoned during the 1980s for anti-Soviet activities) and to moments of visionary architecture (such as Curzio Malaparte's 1937 house on the island of Capri).

For *BAS7*, Kiaer presents a new work focusing on the Russian architect Konstantin Melnikov, who was active until the late 1920s when he became increasingly isolated by Stalinist demands for Socialist Realism in architecture. In defiance of both this edict and of the monochromatic dogma of his contemporaries Malevich and Rodchenko, Melnikov began painting traditional portraits, closeted in his cylindrical house studio, a structure that, as Kiaer states, he had designed as 'a perfect synthesis of building, thinking and dwelling yet, after political censure, it became almost a working tomb for him'. This new work develops from his interest in 'minor' genres of painting – a realm of research that explores the ways in which a marginalised person, group or idea makes use of a dominant language that is not their own – for example, Samuel Beckett writing in French or Vladimir Nabokov in English. This process of deterritorialisation of power shifts both the writer and the nature of language itself. In art today, portraits, still lifes and figurative paintings could be described as 'minor' positions, sitting as they do outside expectations of what 'contemporary' artistic practice is assumed to be. In this, as with other installations, Kiaer creates a transitory and poetic arrangement of allusions, pointing to versions of the world once believed capable of radically transforming lived experience.

Harnessing the formal properties of light reflecting off colour, Kiaer's installations juxtapose watercolours, drawings and paintings with found and gently modified materials – from inflated Korean rubbish bags to office tables, fluorescent-tube packaging, swathes of plastic, deflated footballs and upturned buckets. These installations develop from his continuous research into idealistic and isolated proposals for alternative, and improved, ways of structuring the world through knowledge and architecture. His recurring references include Wittgenstein's studies of language, the sixteenth-century paintings of Bruegel, and Tarkovsky's filmic evocations of light and landscape. He folds these allusions into the specifics of exhibition site and context, each installation extending the premise of its predecessor.

LLF

Endnote, pink (black), 2010 (detail)

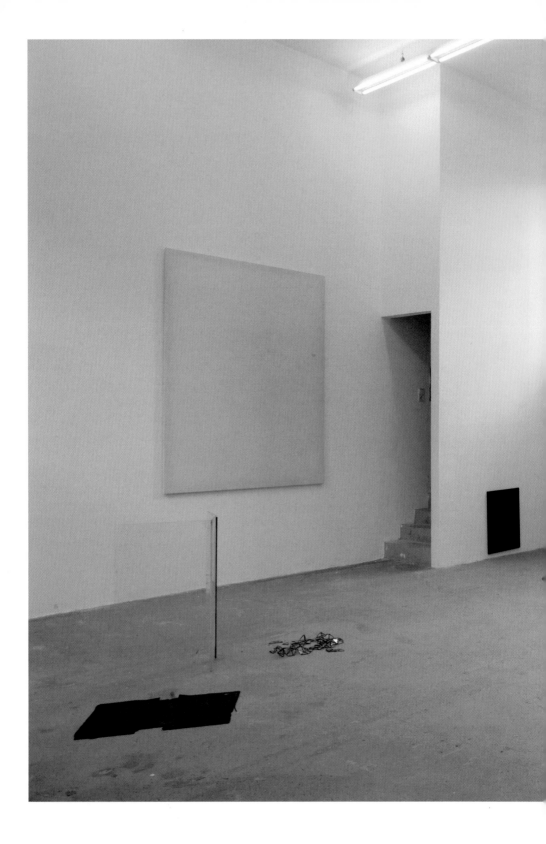

Endnote, pink (black), 2010

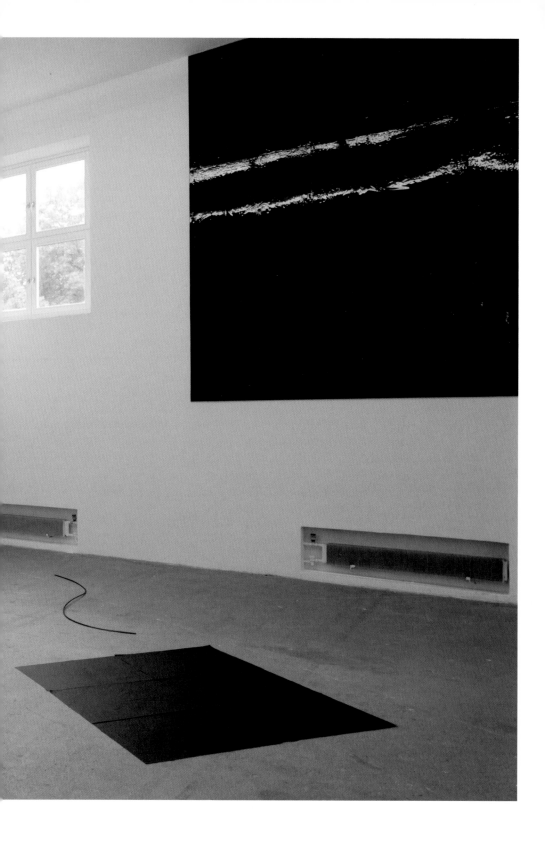

Anja Kirschner
& David Panos

The films of Anja Kirschner and David Panos engage with a multiplicity of historical, literary and popular sources, digging out and radically reworking hidden or obscure narratives in a range of different registers. Methods of story-telling and allegorical associations are engaged to probe the problems and possibilities of class politics, the boundaries of different genre styles, divisions between high and low art, and the difficult question of 'political' art.

The opening words of *The Last Days of Jack Sheppard* (2009) self-reflexively introduce representation as one of the film's central themes: 'Tis as reasonable to represent one kind of imprisonment by another as it is to represent any thing that really exists by that which exists not.' The film tells the story of the last days of the notorious eighteenth-century figure Jack Sheppard, who after repeated escapes from prison, was eventually hanged at Tyburn on 16 November 1724, becoming a popular hero. An emphasis is placed on the process of commodification that the celebrity criminal underwent, through the publication of his 'autobiography', believed to have been ghost-written by Daniel Defoe. Sheppard's activities are set against the backdrop of the frenzied financial speculation that accompanied the South Sea Bubble crisis of 1720, which ruined its investors and destroyed the public's faith in government. His (temporary) ability to evade the system made him an anti-establishment figure, with whom Defoe – himself dogged by debt throughout his life – is shown to have sympathised. However, Defoe's relationship to the exploitative bookseller and publisher Applebee – who is depicted flogging the jailbreaker's story to the assembled hordes at Tyburn for sixpence a copy – remains ambiguous.

The duo's subsequent film, *The Empty Plan* (2010, pp. 95–97), focuses on the German writer Bertolt Brecht, during his years of exile in Los Angeles waiting for the end of the Second World War. The synopsis recounts: 'Although disorientated by the Californian climate and despairing of the alienated, hyper-capitalist culture of Hollywood, Brecht is trying to earn money through screen writing […] Deprived of a theatre or a meaningful artistic context, Brecht spends much of his time revising his past works, and writing the *Messingkauf Dialogues*, a dramatised set of discussions that set out his "theory" of epic theatre.' *The Empty Plan* derives its title from these discussions and 'looks at the changing context for Brecht's work, as the theatre is superceded by cinema and the revolutionary movements that informed his polemical approach are destroyed or betrayed'. Brecht's ideas for the theatre grew out of his experiences of Europe in the late 1920s and early 1930s, when revolutionary movements were strong and widespread. By the 1940s, the revolutionary movement had been defeated and 'Brecht finds himself without a meaningful context for his ideas and facing a political and aesthetic impasse'. The film contrasts Brecht's Hollywood experience with reconstructions of productions of his plays from the 1930s to the 1950s, and examines 'what is at stake in different modes of performance and the different techniques [of] actors'. This is exemplified in the contrast between the dead-pan mode of delivery favoured by Brecht and the more naturalistic technique of Method acting in the US, against which the writer is shown violently reacting in the film.

For Kirschner and Panos, both films seek to address a crucial question: 'What can "political art" actually mean in the absence of a broader "political" culture? *The Last Days of Jack Sheppard* and *The Empty Plan* both investigate the problems involved with art and representation and the way it relates, promotes, inspires, replaces or straitjackets working-class self-activity. Each film looks at art and representation at either end of the "great era" of class politics as it emerged in the nineteenth century […] We are interested in exploring that history, but also in the way that the conditions portrayed in each film might resonate with the present. For all of the veneer of novelty, many of the fundamentals of our society remain unchanged.'
EM

This page and overleaf
The Empty Plan, 2010

Sarah Lucas

Of all the British artists to emerge in the early 1990s, it is perhaps Sarah Lucas who deals most persuasively with the human body and how it is enmeshed in a sticky web of desire and disgust, oppression and resistance, and the tragi-comedy of sex and death. Often made from found materials including beer cans, cigarettes and domestic fixtures and fittings, her work focuses on how sexual identity becomes encoded in everyday objects (a cigar, here, is never 'just a cigar'), and how gender politics are brokered through visual and verbal metaphor.

In Lucas's 1994 sculpture *Au Naturel*, a seamy double mattress slumps against a wall, one side occupied by two melons and a bucket, the other by two testicular oranges and a perkily phallic cucumber, creating a pair of lovers defined solely through slang terms for their breasts and genitals. On one level, this is a marital bed as seen through the smudged lens of pub humour, but it is also a deadpan and slyly subversive exercise in pushing literalism as far as it will go, and a supremely skillful exploration of traditional sculptural concerns, among them materiality, weight, composition and the sequencing of space. The artist has said that: 'Funnily enough […] a dick with two balls is a really convenient object […] It can already stand up and do all those things you'd expect any sculpture to do.' For all its bleary (and very British) atmosphere of bad bedsit sex and building-site innuendo, Lucas's work is as formally rigorous as any Classical marble.

For *BAS7*, Lucas presents a recent series of work entitled *NUDS* (2009–10, pp. 99–101). Here, pairs of tan nylon tights have been stuffed with fluff and fashioned into ambiguous, biomorphic forms, which rest on stacks of breezeblocks set atop simple wooden pedestals. While these sculptures bear some formal resemblance to the artist's 1997 work *Bunny Gets Snookered*, in which sagging hosiery summoned up a woman's splayed legs, they are not so securely gendered. Resembling at once hot flesh and cold stone, they are not quite male, or female, or even quite human. Looking at these bulbous shapes, we think of spilt guts and detumescent genitalia, of skin filigreed with varicose veins and the tender folds of a recently shaved armpit, of fingers crossed against future disaster and the dimpled epidermis of a plucked chicken. Given their tubular forms, we might identify Lucas's *NUDS* as ancestors of Pablo Picasso's sculpture *Head of a Woman* (1931), in which the Spanish artist transforms his young lover Marie-Thérèse Walter's facial features into a series of floppy phalluses, or Louise Bourgeois' *Sleep II* (1967), where a marble glans stirs lazily on a timber plinth. The British modernists Henry Moore and Barbara Hepworth (with their focus on indeterminate organic shapes) might also be detected in the art-historical DNA of these works, alongside the corporeal fragments found in the sculptures, drawings and photographs of the German Surrealist Hans Bellmer. There's a faint echo, too, of prehistoric fertility idols, as though the plump, limestone curves of the *Venus of Willendorf* (22,000–21,000 BC) had been re-imagined in cheap nylon and tumble-drier lint.

Beached on their breezeblock plinths, Lucas's sculptures might be interpreted as meat on a butcher's block, or bodies on an autopsy table, or sacrifices on an altar to an unknown deity, although they are too restless, too squirmingly alive, to be reduced to a single reading. Even their collective title, *NUDS*, simultaneously evokes knots, nodes, nudes and the British slang for nakedness: being 'in the nud'. This phrase usually has connotations of embarrassment or bodily shame, but these social emotions do not seem to apply to Lucas's eyeless and earless entities. Unbothered by the viewer's gaze, they revel in their own polymorphous perversity, penetrating their own orifices in endless loops of pure physical sensation. If *Au Naturel* is, in part, about how visual and verbal depiction is an instrument of control, the *NUDS* series is about how ambiguity might set us free.

TM

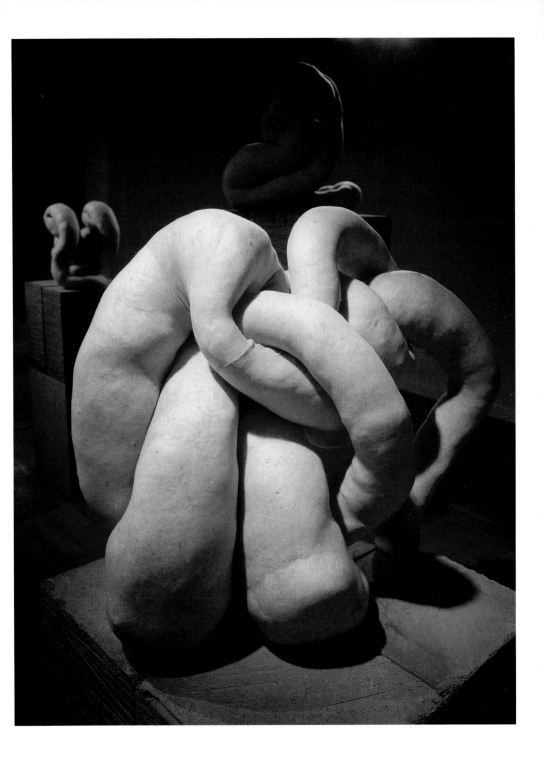

NUD CYCLADIC 3, 2010

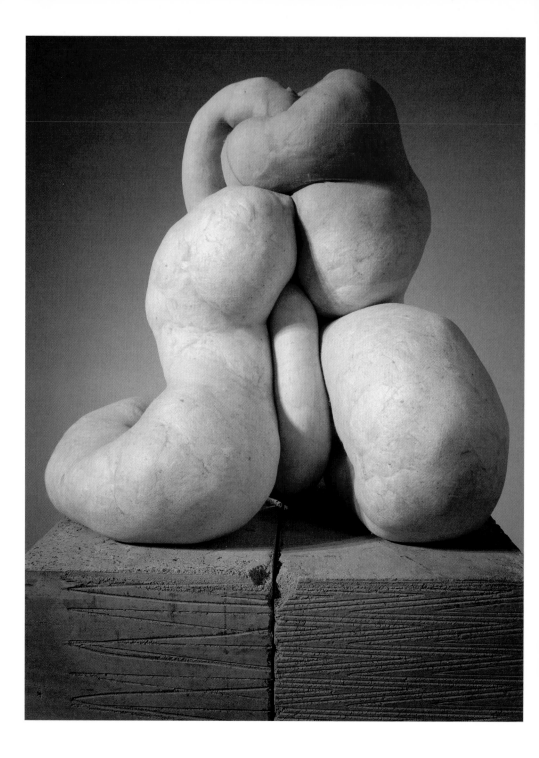

NUD CYCLADIC 10, 2010

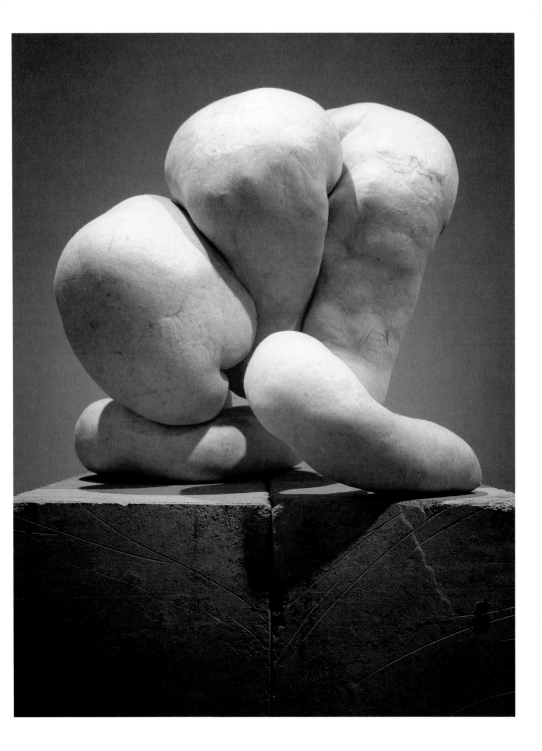

NUD CYCLADIC 6, 2010

Christian Marclay

inspected and aimed. These fetishistic shots – half mating dance, half masturbatory dream – give way to a series of to-camera gunshots, ranging from precision sniping to the manic incontinence of machinegun fire. As the number of assailants increases, the hail of bullets becomes heavier and heavier, and the four screens – each of which stream different clips – fill with the flashing entropy of battle. Suddenly, one of the characters yells 'Stop!', silence ensues, and gunfire gives way to post-coital images of smoking weapons and various marksmen peering out from the screen at the inflicted damage, their faces ranging from the regretful to the unambiguously elated. This lull, however, is short lived, and the gunmen soon resume their shooting, discharging bullets that whistle towards the camera as if to shatter the lens, or some frangible human skull. Played on a continuous loop, *Crossfire* is an endless cycle of violence in which the viewer is not the quarry, but rather collateral damage.

For over three decades, Christian Marclay has subjected sound – or more often the objects and images through which it is created, broadcast and represented – to a series of deft and conceptually deadpan manipulations. From his early work as a pioneering turntablist, to assemblages such as *Footstompin'* (1991), in which three LP sleeves are juxtaposed to create a vision of Michael Jackson as a racially and sexually ambiguous *Rokeby Venus* (1647–51), and the sculpture *Lip Lock* (2000) in which the mouthpieces of a real trumpet and tuba meet in a dysfunctional kiss, to recent prints such as *Blam* (2006), which make use of onomatopoeiac comic book sound effects, he has adopted collage as a strategy to bring the collective pop-cultural subconscious to light.

Marclay's video *Crossfire* (2007, p. 103) is also the product of sifting, cutting and pasting. For this piece, the artist edited together short clips from several hundred movies, from *Bonnie and Clyde* (1967) to *Boyz n the Hood* (1991), each of them depicting a character or characters holding or discharging guns. A four-screen projection that surrounds the viewer, the video begins with footage of what might best be described as the foreplay of arms – fingers fluttering down steely barrels, jacket-fronts being drawn back to reveal gun-filled armpit holsters, firearms from rifles to revolvers being cleaned,

For the Nottingham leg of *BAS7*'s tour, Marclay presents *The Clock* (2010, pp. 104–5), a new work in which thousands of found film fragments, each of them featuring clocks, watches or characters reacting to a particular time of day, have been edited together to create a 24-hour-long, single-channel video. Arranged in order of the temporal moment they depict (a shot of, say, an alarm sounding half past seven will be followed by one of a wristwatch reading 07:31), this sequence of clips forms a functional '24 hour clock', which the artist synchronises with the local time in the territory in which it is exhibited. But while tick, here, always follows tock, *The Clock* does not chart a simple, linear progression. Colour footage combines with black and white, digital with analogue, and scenes set in the past, present and future occupy the same cinematic space. As each new clip appears, a new narrative and mise-en-scène is suggested, only to be abandoned a few moments later, like a decision never taken or an alternate world never explored. Watching Marclay's video, we inhabit two worlds, that of fiction and that of fact, experiencing the persuasive illusion of the passage of time, while being constantly reminded that very real seconds, minutes and hours are flying inexorably by, never to be reclaimed.
TM

Crossfire, 2007

The Clock, 2010

Simon Martin

Simon Martin is preoccupied with what – and perhaps more importantly how – things mean. His paintings, sculptures, photographic and moving-image works patiently examine the ways in which art and artifacts are rendered visible through the mechanisms of display and reproduction, and how their passage through the world is shaped by, and shapes, our wider moment. For the artist, cultural products are not abstractions but very physical presences that cannot be separated out from what he has called, in his 2005 film essay *Carlton*, the 'generalised environment of quote, reference and approximation' in which they exist. This is a tough ecological niche, but some images and objects nevertheless manage to retain an almost unaccountable potency or strangeness. More often than not, it is these that form the focus of Martin's work.

Conceived as a desk sculpture for the home or office, *Untitled* (2007) is comprised of a cheap African figurine bought from a shop in London, placed next to a real, organic lemon. The terms of its display stipulate that both elements must be present for the piece to be complete, and that the lemon must be fresh. This is an artwork that, unlike so much of the stuff that surrounds us, refuses to fade into the background, or to dematerialise into the realm of ideas. Possessed of a faintly absurd aggression, it insists on its own being, and perpetual human attention to it – whoever has stewardship of the sculpture is obliged to replace the lemon regularly, or it will simply blink out of existence. For *BAS7*, Martin revisits *Untitled* (2007) in a new work, *Untitled* (2010). Here, the two sculptural elements are rendered as digital animations illuminated in the manner of the American structuralist filmmaker Hollis Frampton's 1969 film *Lemon*, in which light passes slowly over the titular fruit like the sun across the earth. Some questions occur: is this a representation of the original sculpture, or a work that belongs only to itself? Does the existence of *Untitled* (2010) undo its sculptural predecessor's logic, or do its millions of pixels lend the original a greater weight? What bearing does Frampton's description of his film as 'an image pass[ing] from the spatial rhetoric of illusion into the spatial grammar of graphic arts' have on Martin's digital appropriation of his lighting schema? Does the fact that Frampton's 16mm *Lemon* is now available to watch on YouTube tell us anything about the evanescing of the material world that *Untitled* (2007) protests? Martin does not provide any answers, and perhaps that's the point. The very act of provoking questions reveals the complexity of our contemporary ways of seeing.

Also featured in *BAS7* is a 3,000-year-old stone sculpture of a seated figure from Mexico's Veracruz Olmec culture (p. 107), which Martin has borrowed from the Sainsbury Centre for Visual Arts, Norwich, and displayed inside its usual vitrine, accompanied by its usual label. This is a gesture that not only runs against the remit of the British Art Show (which shows works produced in Britain over the past five years), but also against the accepted protocols of museum and gallery loans, whereby borrowed works are displayed and labelled according to the house style of the host institution. Martin, here, calls our attention to what we might call the 'exhibition-ness of exhibitions', then adds a further layer of complication in the form of *Untitled* (2010) – five pigment prints of an image of a 1971 sculpture by the American Conceptual artist Sol LeWitt (p. 108) – placed in close proximity to the Olmec figure. The Sainsbury Centre is notable for showing ethnographic objects alongside works by twentieth-century European painters and sculptors including Pablo Picasso and Alberto Giacometti, a display strategy that suggests a formal and thematic sympathy between 'primitive' art and a particular strand of figurative modernism. Martin's juxtaposition might be interpreted as a 'what if?' scenario in which such comparisons also encompass (rather jarringly) pieces produced a few years later along the art-historical timeline. As with all the artist's work, it makes a familiar idea unfamiliar, and tunes us into the process of looking anew.

TM

Untitled, 2008

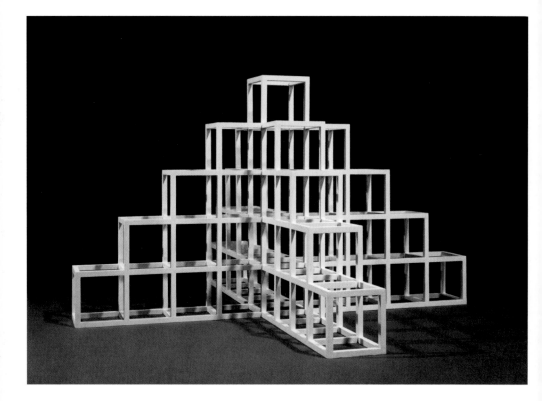

Untitled (After Sol Le Witt), 2010 (detail)

Opposite
Untitled (After Alfred Stieglitz), 2009

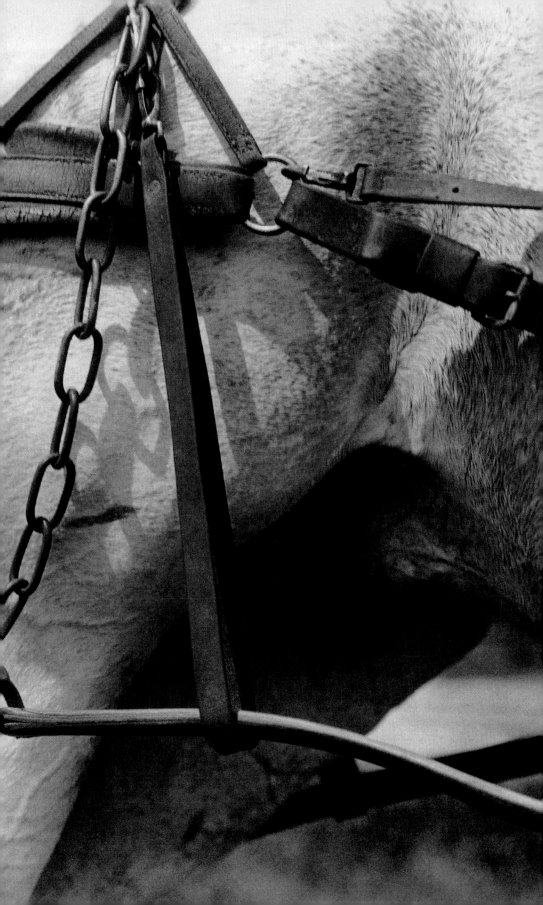

Nathaniel Mellors

At the dark, absurdist heart of Nathaniel Mellors' films – which are often accompanied by animatronic objects and shown in seemingly ad-hoc sculptural environments – is the question of who controls language, why, and how. Drawing on cultural products as varied as François Rabelais' sequence of novels *The Life of Gargantua and Pantagruel* (1533–64), *Monty Python's Flying Circus* (1969–74) and Pier Paolo Pasolini's film *Salò* (1975), he creates parallel universes of horrifying inverted logic, in which the relationship between words and their accepted meanings wobbles and collapses, speech and text become instruments of muddled subjugation, and atavistic desires let rip.

Partially inspired by Chris Marker's *La Jetée* (1962) and Samuel Beckett's *Krapp's Last Tape* (1958), Mellor's film-based installation *The Time Surgeon* (2006) sees the title character trap a disembodied prisoner inside a Sony Portable tape recorder, torturing him with verbal descriptions of bodily violations and using the forward and rewind buttons to send him shuttling through time. We encounter more lost souls in *Giantbum* (2009), a film set in the year 1213 in which a band of adventurers find themselves adrift inside a giant's guts. Their spiritual leader, The Father, returns from a lone search for an exit, during which he has survived by eating, excreting and then eating himself again in a cannibalistic and coprophagic feedback loop that, despite the piece's medieval setting, nods towards contemporary cultural engorgement and recycling. Perhaps to cover up his shame at consuming his own faeces, The Father claims that the group is in the stinking bowels of God Himself, and seeks to lead them to 'salvation' through absorption into the supposed deity's stomach lining. The action is presented in two versions, a rehearsal in a school hall and a costumed shoot in a theatre, and is accompanied by three gabbling animatronic sculptures of the head of The Father – a character who, as Mellors has noted, shifts the action from the 'scatological to the eschatological', while perhaps bypassing the logical entirely.

Created for *BAS7*, and shown in a series of 'chapters' over the course of the exhibition's run, Mellors' new film *Ourhouse* (2010, pp. 111–13) opens with the arrival of a hulking male figure at an English country pile. The house's occupants, a wealthy bohemian family, initially fail to recognise him as human and dub him 'The Object'. It soon becomes apparent that The Object controls language in the house, roving its rooms at night in search of books that (in an echo of *Giantbum*) he swallows, partially digests, and then craps out as a series of odd and foul-smelling sculptures. These objects are both the cause of and the key to a series of fantastical episodes, based on the ingested texts, that the family are forced to play out. Unable to decipher The Object's lexical droppings, and uncertain of the reality of their experiences, the family finds its usual hierarchy, roles and values thrown into disarray. Mellors has described *Ourhouse* as 'British sitcom meets [Pasolini's 1968 film] *Teorema*', which is to say, a world in which individuals are (self-) imprisoned in a life they do not want, crossed with one in which it is only divine intervention, rather than personal fortitude, that allows them to escape. Perhaps, in the end, his work is about freedom – from arbitrary power, from the bindweed of language, and from the way that those things sour us – and just how difficult that freedom is to achieve.

TM

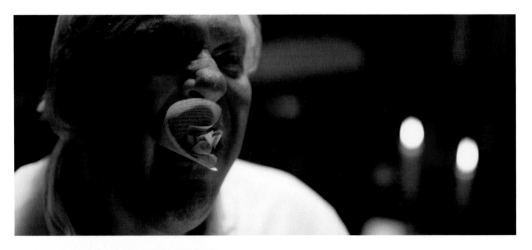

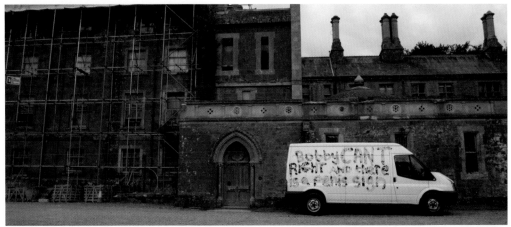

Ourhouse, 2010

Haroon Mirza

Haroon Mirza's sculptures are collisions of objects and sound. His assemblages combine vintage and modern audio equipment with domestic furniture, light sources and recorded material and, sometimes, works by other artists. *BAS7* presents a new installation, *Regaining a Degree of Control* (2010), which claims a space between noise and sound, working with unseen footage of the musician Ian Curtis. Noise is something to reject, an unwelcome annoyance. Sound, on the other hand, has an expectation of a receiver and is welcomed. The artist has said: 'My proposition is to explore visual and acoustic space as one sensorial mode of perception. It is time for art to reclaim acoustic space in order to redress the imbalance where hearing and listening are regarded as less relevant than seeing and looking.'

Adhãn (2008, p. 115), combines a recording of the Islamic call to prayer, abstracted to a point where it becomes unrecognisable, with a looped video clip of Cat Stevens playing acoustic guitar on a cheap television. A desk lamp attached to a low piece of furniture switches on and off, interfering with a Soviet Selena transistor radio, while a close-up film of a cellist is projected onto an upturned vintage guitar amp, and a glass box sitting on a chair steams as wires pass through it. The sounds of the devices and what they are emitting interrupt each other to create a seductive rhythm that draws attention to the relationships between the various elements of the work.

Throughout his works, Mirza combines materials that bring with them implicit associations that have been formed by interpretation and misinterpretation surrounding events and gestures from the recent past. The installation *Paradise Loft* (2009, pp. 116–17) combines sound-emitting devices – including Technics turntables, a 1972 Grundig radio, a Panasonic television and a high-end DVD projector - full of associations related both to the context of their function and to nostalgic use in the present. On one turntable a 12-inch vinyl recording of the 1981 dance floor classic by Sparque, 'Let's Go Dancing', creates a rhythmic, scratchy, crackling noise while LEDs elsewhere in the installation generate a humming bass line. This particular version of the track was remixed by Larry Levan and François K, DJs who held court during the 1970s and early 1980s at the New York nightclubs Paradise Garage and The Loft. The projector and television show fragments of interviews, seen overleaf, with two other pioneers of the underground disco scene in these clubs, Francis Grasso and Arthur Russell, the former the inventor of mixing records across two decks, the latter an avant-garde cellist who, attracted to the minimalist rhythms of disco music, became a record producer. Although predicated on enjoyment, sexual and racial politics charged the social structures of Paradise Garage and The Loft, and as the scene shifted from the underground to the mainstream during the 1980s, radically influenced a milieu far beyond this specific cultural scene.

In the midst of *Paradise Loft* is a sculpture by Giles Round (*MW*, 2009) made from flex and an energy-saving light bulb. It hangs beside a transistor radio, causing a feedback loop as the electricity interferes with the reception. Mirza explains, 'By chance I put a transistor radio next to a lamp with an energy saving light bulb fitted. Instead of treating the buzzing interference as noise, I immediately embraced it as an incidental sound I could explore, a product of old and new technology co-existing in the everyday.'

Mirza frequently appropriates works by other artists in his installations; for example, off-cuts from Guy Sherwin's 16mm film *Cycles #1* (1977–79) and unedited rushes from Jeremy Deller's video *Memory Bucket* (2003) are combined with light impulses and keyboard in *An Infinato* (2009). 'I treat the artwork as any other readymade material in my work,' the artist has said, 'though it's more akin to Marcel Duchamp's notion of the reverse readymade, where he uses the example of taking a Rembrandt off the wall and using it as an ironing board. Just like any other object in my work, I usually assign the artwork with some kind of function, typically a means to a sonic end.'
LLF

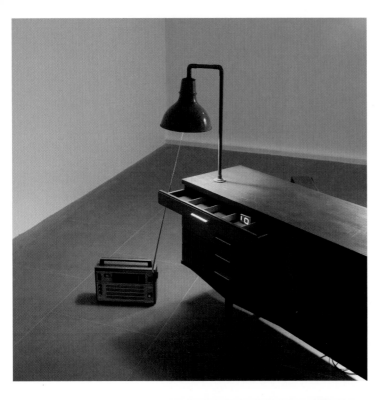

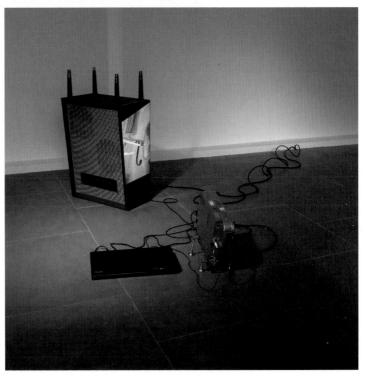

Adhãn, 2008

Overleaf
Paradise Loft, 2009

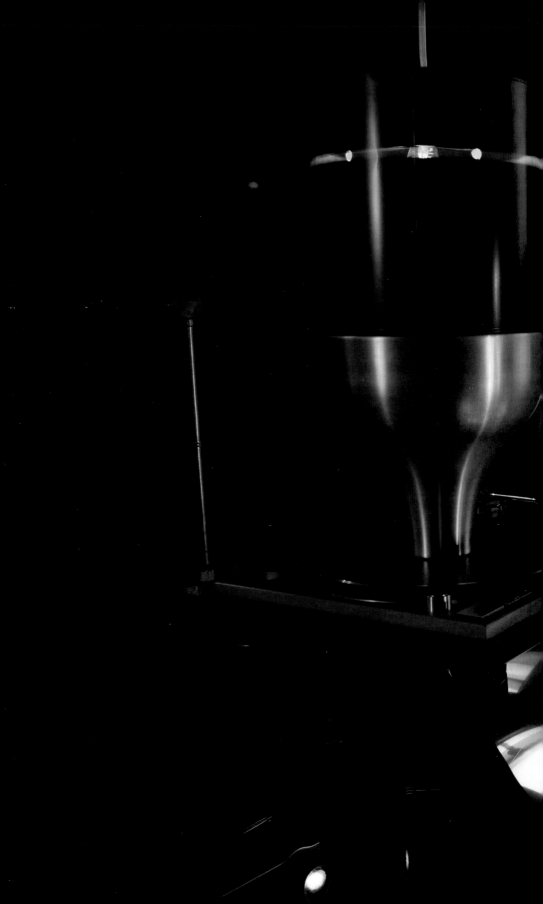

David Noonan

'The idea of collage is central to my work. I take images from different origins and time periods and bring them together to create new narratives.' David Noonan's screen-prints, collages, installations and cut-out figures rework archival images collected in his constantly expanding library of references.

BAS7 shows a large tapestry of a curious scene (pp. 120–21). A hooded figure stands, another sits on a mobility contraption and a third, wearing a jaunty-angled beret, stares ahead from the centre. In the bottom right-hand corner a stretched arm offers up a bunch of flowers. Superimposed peacocks strut, their feather displays yet to be revealed.

Depicted in a palette of grey, black and beige, forms and actions recur throughout Noonan's works as the artist, as he describes, 'overlays an abstract image, perhaps a textile pattern or tapestry, with a figurative image' to create glimpses of unnamed events promising, but never delivering, narratives as seductive as cinematic fictions. Owls and peacocks, birds associated with wisdom and beauty, frequently occupy his scenes. Free-floating moustachioed figures, enigmatic and erudite dandies, stand tall and observe all that surrounds them, like theatrical props around which action might take place.

Noonan's works are journeys into an uncharted theatricalised narrative somewhere between illusion and reality. Documentation of performative actions recurs in his images and figures. Never attributed to a source or location, these actions allude to unexplained, idealised moments of self-expression that could be belief-led, theatrical, drug-induced, pleasure-seeking or, more darkly, divisive power games where the holders of authority are hard to distinguish from those subjugated.

Noonan's untitled works offer no descriptive or prescriptive guidelines, but somehow the images seem familiar – as if borrowed from a recent past, just a generation away, that reverberates in the present. His constructions suggest just-plausible situations that, in spite of their unnerving familiarity, have no meaning and no place in history.

Often Noonan places his pictures and figures within a backdrop of sisal carpet and hessian wall coverings as if staging his own objects for activation by an anticipated audience. To encounter his works is to become unavoidably a part of them. These scenes seem to be private, yet an invitation is being made to join – if only the entry code could be cracked. The implied gestures and rituals seem to offer a seductive alternative, a proposal to believe in something other than what can be articulated or understood, whether a malevolent force or a generous higher power. Just like superstition, Noonan's works are something to be wary of, yet they have a powerful draw in their unexplained proposal of how to occupy the present.

LLF

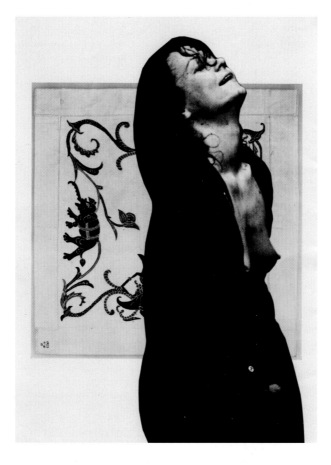

Untitled, 2009

Untitled (Tapestry), 2010 (work in progress, under
production at the Australian Tapestry Workshop)

The Otolith Group

The Otolith Group was formed in 2000 by Anjalika Sagar and Kodwo Eshun, who named themselves after the term that describes the part of the inner ear that senses tilt, while developing their ideas for the first film in the *Otolith* trilogy.

Otolith I, made with Richard Couzins, is set in a future (the year 2103) in which humans are no longer able to survive earth's gravitational pull, having spent prolonged periods in microgravity conditions on space stations, causing their otoliths to swell and deform. The film centres on the real meeting of Sagar's grandmother, Anasuya Gyan-Chand (1902–95), a leader of Indian socialist women, with the first woman in space, Valentina Tereshkova (born 1937). It is told through a series of fictional diary entries and correspondence between Sagar and her grandmother, set within the larger narrative of Sagar's imagined descendent, Dr Usha Adebaran-Sagar, told from perspective of a fictional space station from which 'earth is only accessible through media'. This narrative is intercut with super-8 footage from Sagar's family history and digital imagery of the 2003 anti-war protests in London, weaving the past, present and future together in a meditation on the interrelationship between the personal and the geopolitical.

As it moves between its different sources, the film focuses on incidental detail, close-ups that deny a sense of the whole, and the segueing of imagery in and out of focus. Eshun has referred to the *Otolith* films as being 'high international documentary style […] the kind of experimental documentary or the left wing essay that was always our obsession', tracing the group's line of evolution from Dziga Vertov through Chris Marker and Black Audio Film Collective to Harun Farocki. He has said: 'We spend a long time thinking about how to create an image [that] refuses the expectations or refuses the pleasures of what an image is. And I think that's partly the essayistic [approach, which] is dissatisfaction, it's discontent with the duties of an image and the obligations of a sound.'

While *Otolith I* examines history's power to create the future, from a space far removed from earth, *Otolith II* returns to the planet and its expanding human population with an exploration of contemporary Mumbai, firmly located in the culture of global capitalism. Here the mega slums – psychological 'crucibles' for testing humanity under extreme pressures of labour – coexist side by side with an increasingly sophisticated film business where advertisements for financial products, utterly inaccessible to most of the impoverished slum inhabitants, are being painstakingly crafted in film sets located in the ruins of former textile mills. In a continuation of the first film's evocation of modernist utopian dreams, *Otolith II* lingers on imagery of Le Corbusier's planned city, Chandigarh, where, as Dr Usha recounts, the architect set out to control and conquer the sun.

While not answering the question asked by its narrator in *Otolith II*: 'Why do Indian artists produce so little science fiction?', *Otolith III* would appear to reflect on it. This final part of the trilogy imagines the making of *The Alien* (1967), an unrealised film by the Bengali filmmaker Satyajit Ray. Ray's script describes the extraterrestrial visitor not as hostile and destructive, but as peaceful and friendly. In an interweaving of imagery and sound from such diverse sources as old black-and-white Indian films and contemporary colour digital footage shot on location in London, candidates for the parts of the director and the film's protagonists – the boy, the journalist and the engineer – are proposed by picking out individuals spotted on crowded streets. The boy's words, 'We are unfinished characters with interrupted biographies', have a poetic resonance that reaches beyond the plot of the film to a universal questioning of individual potentiality. The endless multiplicity of future possibilities, lost through history, that is invoked in this film, is a poignant unifying thread that runs throughout the *Otolith* trilogy.

EM

Otolith I, 2003

Otolith II, 2007

Otolith III, 2009

Otolith I, 2003

Opposite
Otolith III, 2009

Mick Peter

Mick Peter's sculptures are cumbersome objects that teeter slapstick-like on the edges of bad taste, indulging in sleight of hand and visual deception. *Two Clerks* (2007), for example, is a giant pair of playing cards that appear to be made from cast concrete, holding each other up by sheer brute force and shackled together with cast-rubber belts. Their seeming heaviness, though, is a fiction – these are near-weightless polystyrene sheets, incapable of supporting anything but themselves.

Two Clerks takes its name from the characters in Gustav Flaubert's novel *Bouvard and Pécuchet* (1881), a frequent reference point for Peter. Flaubert tells the tale of a pair of copy-writers who inherit a fortune and set out to increase their knowledge. Armed with an expanding library of reference books, they try their hand at a great number of intellectual disciplines – including museology and distilling alcohol – but since they swallow wholesale the received ideas in these books, refusing to analyse information or synthesise conflicting positions, their endeavours end in complete failure and they become increasingly confused and bewildered. Eventually they settle on the task of copying and cataloguing everything that comes into their possession, without engaging in any way with content. In this endeavour, they finally find an activity free from ambiguity and full of incontrovertible truths. Peter's works often point to the futility of list-making, categorisation and authority, through references that fly from Nikolai Gogol's absurd satirical story *The Nose* (1835) to Frank Zappa's 1971 frenetic film *200 Motels*, via the drawings of Saul Steinberg and the laboratory-museum recounted in Raymond Roussel's *Locus Solus* (1914).

In the sculpture *Moldenke Fiddles On* (2008–9, pp. 128–29), approximations of architect's drafting tables – obsolete tools that have long been replaced by digital drawing programmes – have been covered in red-pigmented latex. Made from an assemblage of found materials, the tables are bound together by a sagging latex saw. Measuring instruments from a school mathematics set have been appropriated as weapons to puncture their surfaces. The use of vibrant colour and surprising materials are established gestures in the canon of sculpture, but in Peter's hands these traditions are employed with an unruly, comic irreverence. 'Moldenke' is a reference to the luckless pro-tagonist of what Peter describes as 'a kind of spaced-out quasi sci-fi novel by David Ohle, titled *Motorman*, that plays with the pitch of language in an amazing amorphous way. There are lots of startling substitutions of material and texture. He talks about a jellyhead boy squirting "jelly from an ear valve" and how another is lying "deflated" on a mattress. This collapse and integration of objects really motivated this piece and also informs the way in which I combine and transform elements in my drawings.'

Peter's playful and irreverent drawings often bear the same titles as his sculptures, yet take a completely different turn. In *Bouvard and Pecuchet* (2006), he uses spray-paint, ink and pencil on paper to depict Flaubert's clerks, pre-sumably engaged in one of their literal-minded experiments: one is giving a pig a piggy back, while the other is receiving one. In the ink and pencil drawing *Pecuchet* (2007) a van crashes into the word 'Pecuchet', while the head of a grumpy-looking monster looks on, and a figure lies helplessly inside the vehicle, surrounded by his scattered tools.

Fascinated by comics and obscure science fiction as much as he is by literature, Peter lampoons the notion of authority in his works. His humorous sculptures and drawings pro-pose the perverse idea that the most effective communication can take place through misun-derstanding, and that ambiguity and doubt hold the greatest currency for making sense of the present.

LLF

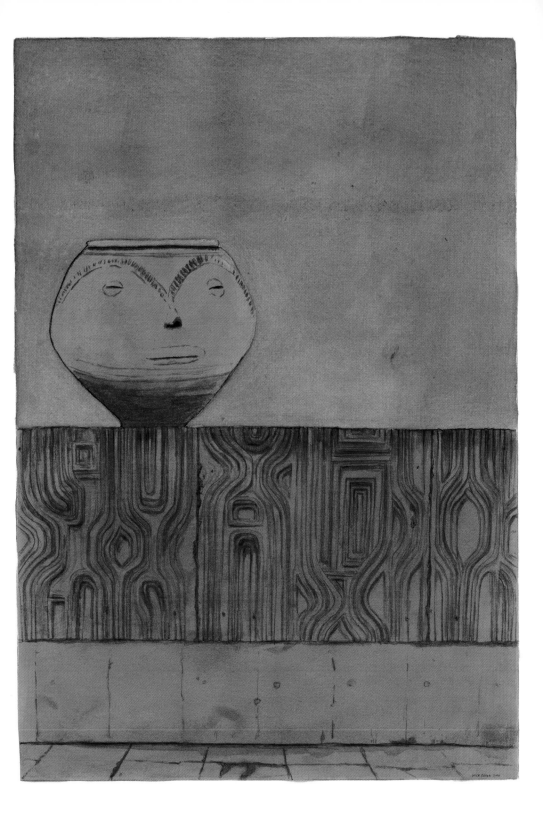

Wall Relief With Terracotta Chad, 2010

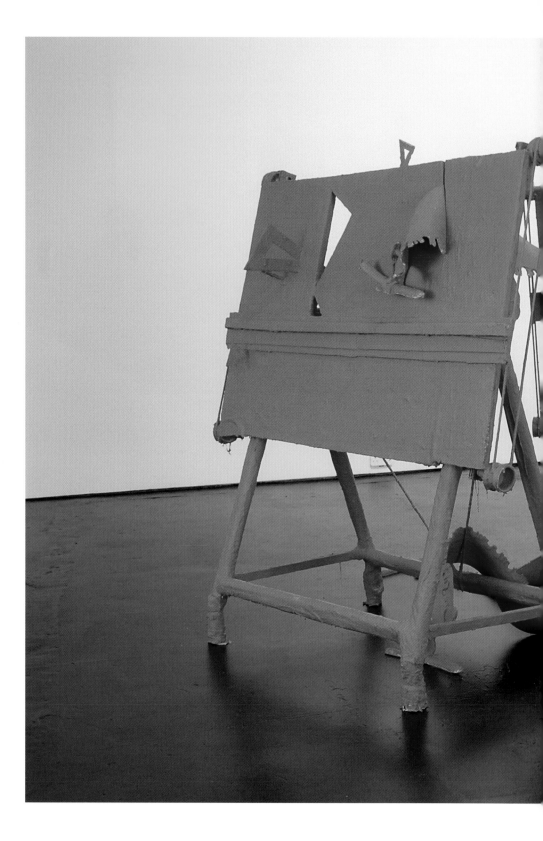

Moldenke Fiddles On, 2008–9

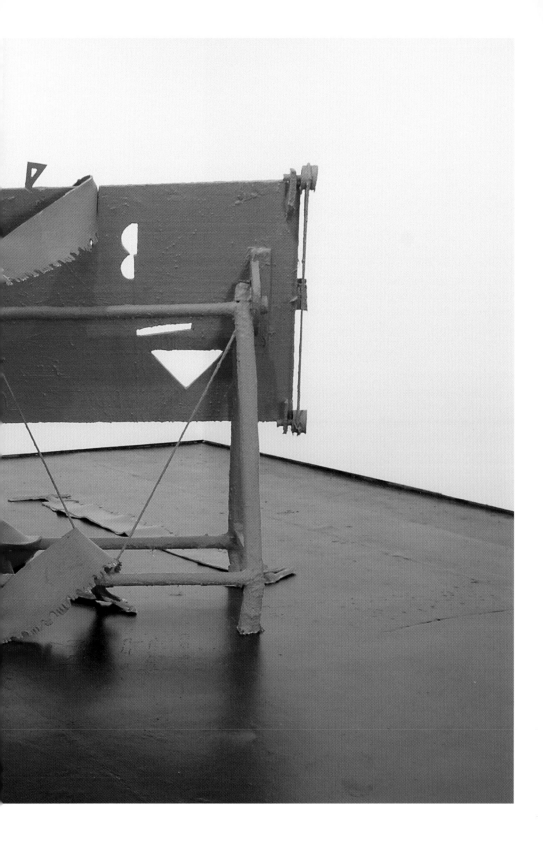

Gail Pickering

In her videos, performances and sculptures, Gail Pickering charges the present with the resonances of cultural history to explore the boundaries between the authentic and mediated, the immediate and the archived, identifying the ways in which history influences the present through both fiction and fact. Constructing scenarios from specific historical sites, political events and coded behaviours, she develops her work through collaboration with amateur and professional actors, whom she encourages to improvise within a tightly directed framework.

In *Zulu (Speaking in Radical Tongues)* (2008), for example, a performer collages proclamations by radical 1960s and 70s political groups, which have been sourced from original diaries and manifestos, with scripts from cinematic representations of revolutionary action. Within a sculpture that spells out 'ZULU' in plywood letters, just large enough to fit a human body, the performer channels the texts while making choreographed physical gestures that have been appropriated from urban guerrilla groups, communes and their cinematic counterparts. As the material from 'original' and 'performed' sources intertwine, the sources become indistinguishable from each other. Similarly, in *Dissident Sunset* (2008, p. 131), actors restage photographs from twentieth-century rebel meetings within a cardboard set, creating carnivalesque versions of resistance.

Filmed inside Robin Hood Gardens, a late 1960s London housing estate designed by the New Brutalist architects Alison and Peter Smithson, *Brutalist Premolition* (2008) depicts a resident family casting professional actors in their home to play themselves. Adorned with ornaments and memorabilia, their home subverts the planned austerity of the modular modernist architecture; captured on film, it takes on an identity of a decorated 'real' set within which the operations of life unfolds.

The actors, once minor characters in the television soap *Eastenders*, perform intensive melodramatic fragments from their past repertoire. As expectations of soap opera and reality television collide, the professionalised acting jars with the banality of domesticity that, perversely, becomes somehow less authentic than the fictional versions of family life.

Hungary! And Other Economies (2007, pp. 132–33) also collapses expectations of acting styles and ideologies in a presentation of Peter Weiss's Marxist 1963 play *Marat/Sade* filmed at the Marquis de Sade's castle in Lacoste, a ruin now owned by the fashion designer Pierre Cardin. Dressed in counterfeit versions of Cardin's 1960s futuristic designs, the actors, all from the French pornographic film industry, self-consciously experiment with their roles as they test out Weiss's study of personal versus political revolution. Pickering describes how 'the actors have an idea of what they perceive "real" acting to be, as opposed to their day job. They are playful with the script, they improvise their own versions, and seek common ground in the explicit, cruel, violent language of the script with the casual framing of porn production.'

In *BAS7*, Pickering presents a new work that extends her interest in forms of socio-political theatre, working with the historical precedent of live television broadcasting, as seen, for example, in the British series *Armchair Theatre* (1956–80) and *Play For Today* (1970–84). The work begins with a unique performance broadcast live from her studio in London to the first stop of the exhibition in Nottingham. *Sixty Six Signs of Neon* (2010–11) takes its title from a little-known American exhibition of outsider art that presented sculptures made from the burnt-out detritus of a violent political demonstration. Working from this reference as a metaphor for live film montage, the screened performance is seen as it is performed. Close-up fragments are interrupted through vision mixing and the insertion of pre-recorded material. The historical form of gritty British social realism is remade into discordant choreographed gestures as Pickering's collaborators 'stage' their own image, fully aware that their actions are being perceived within the irreproducible environment of live broadcast.

LLF

Dissident Sunset, 2008

Overleaf
Hungary! And Other Economies, 2007

Olivia Plender

While the basis for much of Olivia Plender's work is research (which has often focused on nineteenth and early twentieth-century religious and social reform movements such as Modern Spiritualism and the Kindred of the Kibbo Kift), her drawings, graphic novels, performances, videos and installations are less concerned with creating authoritative accounts of the past than with examining what she has called 'the ideological framework around the narration of history', and how it impacts on present-day political and cultural concerns. In her 2009 exhibition at Gasworks, London, *AADIEU ADIEU APA (Goodbye Goodbye Father)* she employed ersatz Victorian posters, a pastiche tourist-information film, and remade architects' models to track the links between the preening colonialist showcase of the 1924 British Empire Exhibition, the UK government's recent use of anti-terrorism legislation to seize Icelandic bank assets, and the looming spectre of the 2012 London Olympic Games. Here, the inauthenticity of the items on display underscored the political bad faith of the enterprises that they supposedly documented – a desire to flex atrophying imperial muscles rather than to explore more equitable relationships at home and abroad.

For *BAS7*, Plender presents *The Lost Works of Johan Riding* (2010), a project created in collaboration with Craig Burnett and Nick Santos-Pedro that seeks to recuperate the vanished oeuvre of a fictional filmmaker active during the 1970s and early 1980s though a series of surviving artifacts, among them movie posters, props, script pages, photographs and handwritten correspondence. Central to this metafiction is the figure of Dr Roger Quallen, an academic whom we are told chanced upon Johan Riding's story while watching late-night TV and resolved to discover everything he could about the director and his work, writing his biography and gathering the fragments of his lost films into a book. As Quallen puts it in his introduction to this collection (also entitled *The Lost Works of Johan Riding*):

> It is my aim to sweep up the dusty tail of his comet, to recover the residue of his brilliance, to assemble the scraps and remnants of Riding's work that have come to light over the past decade. And yet it would be grossly inadequate to merely salvage this ephemera, or to revel in the beauty of Riding's ruins; it is essential to collect into a coherent whole the fragments, relics and memories of the lost works, to heal the wounds of the lost plots, to restore Riding's dismembered body of work to some semblance of wholeness.

Such an endeavour, of course, is bound to end in failure (there never were any films to be lost, or a Riding to make them or a Quallen to piece their fractured leavings together), and this project by Plender, Burnett and Santos-Pedro might be best read as an investigation into how a missing, or even non-existent, text can be summoned up through marginalia, and how historical evidence is no guarantee that a particular history occurred. Fresh accounts of Riding's work will be presented in a variety of forms over *BAS7*'s run, from live talks by 'Quallen' to textual and visual material.

A fiction about fiction, *The Lost Works of Johan Riding* operates on several different planes of reality, all of them subtly unstable. Is it possible that Riding and his films are merely a figment of Quallen's imagination, and if so what does it mean for one character to create another, and what then is the status of ephemera on view in the gallery – fakes, faked fakes or something else entirely? Plender, Burnett and Santos-Pedro (and the further collaborators whom they plan to recruit to the project) have created a narrative puzzle without a solution, in which voids appear almost solid, and tangible truth is always beyond our grasp. TM

Olivia Plender in collaboration with Craig Burnett and
Dr Roger Quallen, *Poetry Marathon*, 2009

A TRUE DRAFT OF THE WHALE AS IT WAS SEEN IN THE RIVER THAMES

A monstrous fish made its appearance in the great river Thames in the capital of London, in the year two thousand and six. She was first discovered near the shore of Westminster, seeming drawn to the City from where she progressed to nearby the Houses of Parliament. An ill attempt at rescue was made to no avail. The bad result was the death of the horrible monster and therefore such a wondrous rare sight can only be interpreted as a celestial warning. The calamitous events that in the following year turned the whole financial world upside down bear out this view. The curious and the informed will be aware that the monster's name derives from the Latin monere (to warn), signifying a divine portent — though not the government, the bankers, nor the public could at that time read the sign. This Whale was 57 foot in length and near 40 foot about, she is more in height than in breadth and is taken to be a matter of 50 tunn in weight.

The Thames Whale, 2009

Opposite
Nutmegs, 2009

Don't take any

WOODEN NUTMEGS!

A NOTICE TO THE PUBLIC INTENDED AS A WARNING AGAINST FALSE REPRESENTATIONS

Recently it has come to the attention of the authorities that there has been a proliferation of

PEDLARS

about the place selling a variety of

BOGUS

or otherwise false goods &

VICTUALS

Amongst these profligate products you will find
CARVED WOODEN NUTMEGS,
PAINTED PINK HAMS FIT TO BREAK YOUR TEETH,
CARVED CIGARS, WOODEN PUMPKIN SEEDS &
STOCK PORTRAIT PAINTINGS.

Who is responsible? It is generally thought that Nobody is responsible,
though a small minority say that it may be Somebody.
Any information leading to the capture of the aforementioned Nobody will be rewarded.

Elizabeth Price

Elizabeth Price works with found and invented archives, investigating and testing ways in which things are recognised and organised, as well as how objects and systems mutate through the passage of time. *User Group Disco* (pp. 139–41) is the second video in an ongoing series entitled *New, Ruined Institute*, in which each episode takes place in a different room within a fictional institutional building. The videos are composed of a bricolage of black-and-white moving images, across which text collected from a range of sources unfolds in varying colours and typefaces. Created by Jem Noble, their soundtracks employ a similar method of mixing, combining melodies from such musicians as the Cure, Desmond Dekker, A-ha, Joy Division and the film-maker John Carpenter. Price has described her videos as 'a solution to bringing text, image and narrative together, so they resemble advertising, the infomercial, corporate and pedagogic uses of PowerPoint […] they […] are all structured as tours led by fictional narrators – collective entities (committees or human resource departments) that are simultaneously didactic and unreliable. I use this unified/divergent voice as an excuse for all kinds of digressions and connections.'

User Group Disco opens onto a black space, identified as the 'Hall of Sculptures', in which lies a single mannequin leg. In short phrases that run sequentially over the screen, suggesting that we are being instructed by a computer, the narrator's voice elaborates the purpose of this place. Alternating the quasi-religious or spiritual with the banal logic of a corporate presentation, the speaking 'Human Resource' lists the 'parts' of its system. The words 'Generating Core', 'strategic apex', 'technostructure', 'ideology', 'authority' and 'decision processes' run over images of rotating mechanical parts, recalling the complex mechanical fountain made of chrome ducting, wheel hubs, racks and display stands supporting bubbling chocolate fondue pots that features in the series' first film, *Welcome (The Atrium)* (2007).

The digitally synthesised soundtrack that accompanies these 'strange and miscellaneous fragments' reinforces the sense that the scattered debris littering this Hall of Sculptures belongs more to the operations of a factory than to the realm of art. The factory is where the decision process is undertaken – the 'operating core' in which sculptures are created through being classified by the system, which we are inside. However, the narrator warns, 'works of art can shock the unwary by their relation to accumulated Domestic Monstrosities'. The phrase 'monsters have not been eradicated' blazoned across the screen in large red capitals recalls the graphic advertising interventions of Barbara Kruger.

The viewer is invited to taxonomise a range of gleaming ceramic objects that revolve against the dark background leading to a spiralling light and a rotating record identified by the narrator as an object 'already too old not to present us with riddles'. Revolving on its turntable, it is accompanied by an excerpt from a description of a whirlpool by Edgar Allen Poe. As the camera lingers on a rotating glitter ball – the very heart of the disco – its multiple mirrors splintering and reflecting light in all directions, the text lists ranges of articles that are floating in the matrix of the 'taxonomic universe'. For Price, dissolution is as much the point as collection and organisation.

As the texts take on a visionary tone, the camera dwells pleasurably on the gleaming surfaces of kitsch pottery objects based on eroticised female bodies. The closing words, 'You will understand that you too are a mere appearance dreamt by another', suggest final dissolution. As in Price's earlier film, *At the House of Mr X* (2007), which hyperbolically celebrates a collection of art objects in the modernist home of an anonymous collector, notional human bodies erode and fuse with the objects making up the collection. Price's camera typically aestheticises these, reinforcing the notions of desire and consumption in which we are all complicit, while emphasising the contingency of the underlying system of classification that creates value hierarchies. As she comments: 'I don't want my work to be seen as institutional critique, but perhaps as one of its descendents. I'm interested in working with it not as a failed project but as an unfulfilled narrative.'

EM

User Group Disco, 2009

they will not bite into your fle

Karin Ruggaber

The architectural façade as both image and material is central to Ruggaber's *Relief #90* (2010, pp. 144–45), in which a large number of organically shaped tile-like fragments cluster in small groups and spread unevenly across the wall. Each of the individual parts of this work is cast from a mould using concrete and plaster, often in sections, and incorporates incongruous shards of tree bark and basic building materials as well as art materials such as pigment and spray paint that add colour in a range of brick and stone tones. While the sections of concrete and plaster on a wall inevitably evoke the surface of a building through their materials, their rough texture, organic layering and curving forms take the work into a less easily recognisable realm. Their spatial organisation on the two-dimensional surface of the wall becomes a composition more suggestive of the pictorial space of painting than that of sculpture.

While some of Ruggaber's relief works play with figuration, portraying stylised representations of animals, others, like *Relief #53* (2008, p. 143), present groupings of shapes with the possibility for multiple organic associations. Reliefs made of large numbers of similar parts – such as *Relief #58* (2008) – employ a method of fanning or incremental development, the edge of one element implying the form of the next until a new form – made up of tightly clustered parts – is intuitively reached. With its loose and non-systemic arrangement of parts and the wide scale of its extent, *Relief #90* denies vegetal and animal associations. As Ruggaber has commented: 'It has a focus point and a direction like a landscape, without being pictorial or descriptive of it. Some parts are repeated, copied, mirrored and enlarged. Pattern isn't the right word, as it implies too much of a logic, and yet I'm interested in a mechanical flatness and repetition, and in the point at which the flat non-representational becomes readable, becomes image. It is a kind of tableau, and in this sense it contains and plays with the elements of scenery, such as a focal point, background and foreground.'

Materials that cover and protect have also found their way into Ruggaber's sculptures in the form of clothing fabrics such as tweed and silk, which at times are set into poured concrete. Presented horizontally, these objects might suggest remnants from an archeological dig. However, rather than depth, Ruggaber is interested in surface physicality, explaining: 'The façade is both an actual and a representational skin, in that its materiality speaks about the status of a building or the content of it, as well as structurally holding together and differentiating between inside and outside.' Caught between thresholds of readability and functionality, and matter in a state of pre-form or pre-naming, *Relief #90* follows its own internal order to describe an arrangement of two-dimensional objects in space with multiple associations.

EM

142

Relief #53, 2008

Relief #90, 2010

Edgar Schmitz

Edgar Schmitz has described himself as 'an artist working on the politics of confusion and ambient attitudes'. Unusually, he is perhaps almost as well known for having an exhibition named after him as he is for making exhibitions himself. In 2005, the British artist Liam Gillick was invited by the ICA, London, to create a display structure for an archive of art-publishing projects. He extended this invitation in turn to Schmitz, who became his collaborator and, as Gillick put it, 'the title and content' of the show. Given that an inventory of the exhibition's contents included not only the archive, Gillick's structure and Schmitz's contribution (a loop of mute footage derived from Rainer Werner Fassbinder's 1979 black comedy about German domestic terrorism *The Third Generation*, and a mutated version of the film's soundtrack that played on separate speakers in the gallery's concourse) but also a collaborative work made by the American artists Christopher Wool and Josh Smith, this was clearly not a 'portrait' of Schmitz in any conventional pictorial sense. Rather, the show suggested a particular cast of mind – one uneasy with the authority that is usually invested in the apparatus of an exhibition (titles, authorial attribution, even the theme and choice of works), and one eager to explore what new possibilities open up when these sites of artistic and curatorial production are upended, reconfigured and transformed.

For *BAS7*, Schmitz has developed a new set of works employing projected video and manipulated found sound recordings that will inhabit 'threshold' spaces in the exhibition venues of each host city – among them gallery foyers, staircases and gift shops. Their collective title, *To Go with the Comet* (2010/11, pp. 148–49), references *BAS7*'s subtitle, 'In the Days of the Comet', and suggests that they accompany the show in time (if not quite space), but also that they have an ambiguous and self-selected degree of distance from it. Taking as their point of departure the notion of the cinematic trailer – a cultural artifact that does not quite exist on its own terms, but rather condenses, exaggerates and seeks to create an appetite for the film it promotes – Schmitz's works are designed to be encountered before the main body of the show, and to set an ambient tone that both orients and disorients the visitor.

In the video pieces, Schmitz presents looping footage of what might best be described as 'background information', among them bubbles foaming on the periphery of a scene from an anonymous Disney cartoon, a snowy mountain scene found on the cardboard backing of a set of stickers purchased in South Korea, and a stylised grass lawn printed on the packaging of a child's toy zoo set. At once very literal and perversely formalist, this is the sort of imagery that we usually ignore, or only catch in the corner of our eyes – the bedrock to more pressing or seductive visual experiences. The source material for the sound pieces is equally minor, and equally ever-present in our lives. Here, Schmitz has sampled the audio from the 'idents' of South-East Asian TV and film production companies that appear (like the roaring MGM Lion, or Columbia Pictures' torch-bearing goddess) before a broadcast or feature presentation. Played on speakers placed some distance from the projected images, these recordings, with their swooping, celestial music, suggest the twinkling of heavenly bodies, or comets burning through the skies. The promise of escape is an important aspect of *To Go with the Comet*. While the work provides, in its oblique way, a portal into the wider exhibition, it also perhaps functions as a rabbit hole or escape hatch – offering passage into a cartoon backdrop, or a filmic fantasy glimmering on the edge of possibility.

TM

Some Disappearances and a Bit of Noise, 2009

Opposite
To Go with the Comet (*Seoul snow*), 2010
To Go with the Comet (*bubbles*), 2010
To Go with the Comet (*zoo set*), 2010

Above
To Go with the Comet (tap), 2010

Maaike Schoorel

Maaike Schoorel's paintings are sonic fields of atmosphere. On first encounter, they appear devoid of any representational content, but after just a short time, contingent on the peculiarities of each person's vision, figures and settings emerge from the mass of paint as light bounces OFF the textured surfaces. Quickly, though, the recognisable forms are lost again as the eye becomes distracted by a detail of mark-making – perhaps some red describing a flower, maybe a curve of a fountain, or a pair of bright blue eyes. These are works that make demands on one's time, calling for perception to be slowed and for looking to become more intense.

Most of Schoorel's paintings start with a photograph that is found – torn from a magazine, taken from a family album – or shot by the artist herself. The photographs and poses are chosen for their over-familiarity and employment of immediately recognisable codes and conducts. Some use traditional genres of painting and art-historical scenes, from the self-portrait to the still life, bathers to formal gardens. In others, the references are to family and social events, taken from holiday snaps and home movies that capture specific personal memories in generic images. A few are painted from nude studies of strangers in their homes. In these, the sitters assume the customary poses of naked portraits that have been established through conventions of both painting and photography.

Once chosen, the photographs are transposed by eye onto canvases that have usually been prepared with OFF-white gesso, gently tinted yellow, pink, green or blue. Rather than creating a point-by-point analogy of the source image, Schoorel embraces unpredictability to enable the painting to take its own course. All excess information is removed as the paintings are built up in layers; sometimes paint is thinned with turpentine, at other times it is thickened with epoxy resin. The resultant barely there images communicate with the least possible volume, defying their own status as representations.

Selected for *BAS7* is a suite of self-portraits, all painted in 2010. In each, Schoorel works from photographs that she has taken of herself in archetypal poses – as the reclining nude in a landscape, sitting on the edge of a bed, lying in a bath, or working in the studio, turning towards the camera, brush in hand. In all save one, a field of thick white noise draws the eye into the painting as it hums with pastel interruptions. A single small work has been made, for the first time, in black (p. 151). The surface is pinpricked with gentle colour, falling into its own darkness.

Schoorel refuses to define painting as a device for portraying what can be seen; instead, her canvases study the processes of looking. Her figures recede and move into view, their borderline invisibility charged with the memory of a glimpsed presence. These paintings are reminders that seeing is as much about what cannot be seen as what can; as much concerned with process as end result.

LLF

Self-Portrait in Black, 2010

Overleaf
Emma-Louise from Above, 2008 (left)
Monica in her Living Room, 2008 (right)

George Shaw

The ostensible subject of George Shaw's paintings is Tile Hill, the suburb of Coventry where he grew up in the 1970s. Designed in the aftermath of the Second World War, the housing estates of the area were intended as a means to usher in a new future, conceived for workers employed in the thriving local car industry. Such ideals were short lived: in the 1970s and 80s the decline of the motor industry pushed unemployment up to over 20 per cent, ushering in enforced leisure time and small-town frustration.

In the mid-1990s Shaw left Tile Hill to study and began to depict the area in detailed paintings, working both from memory and snapshots. All identification marks, however, are removed in these paintings; skies are after-rain grey and there are no road signs, pub names or people. Shaw's choice of Humbrol enamel paint, a medium with no art-historical associations, reflects the obsessive adolescent activity of making model aeroplanes – a task to while away time when there is nothing else to do. His paintings are evocations of what it is to be a teenager waiting to grow up, leave and move on.

Shaw's task is one founded on repetition. Having long left the area, his returns are filled with endless failed attempts to re-find a remembered version of the past. He takes hundreds of photographs of places that are fixed in his memory but have changed with the passing years: football fields, the edges of the Forest of Arden that borders Tile Hill, pubs where his family whiled away wet afternoons, streets where he once hung around. Neither carefully composed nor digitally achieved, these chemist-processed snaps stop the passing of time for a fraction of a second. They are then used as starting points for paintings that, in spite of their representational eloquence, are not simple representations. Often painting the same sites again and again, Shaw patrols the past to mine the ways in which it becomes located in the present through, on the one hand, the partial and unreliable processes of memory, and on the other, the scarring of an area by macro-economic conditions.

The three paintings selected for *BAS7* mark end-points. *The Next Big Thing* (2010, p. 155) shows a pub knocked down to make way for new homes, with little regard for who might want to live in them; *Your End* (2010, p. 155) a wall at the end of a football pitch that has been tagged with graffiti whose meaning is indecipherable to Shaw since these marks belong to a disaffected generation different from his own. *The Blocked Drain* (2010, pp. 156–57) depicts a worn-down residential street, scrubland to the left. This is a site that Shaw has painted before: *The Garages* (1997) and *The Anniversary* (2004) show it lined with garages, built for imagined prosperous car-owning families. Never used as planned, these lock-ups became places to break and enter or to dump unwanted furniture. Now, the garages have been demolished and the end of the street is marked only with a waste bin; it has been raining recently and the drain in the centre of the street has stopped doing its job. 'My thinking in the making of this painting,' explains Shaw, 'can be summed up by the thoughts of Thomas Hardy's Tess: "Time would close over them; they would all in a few years be as if they had never been, and she herself grassed down and forgotten."'

Shaw points not to the idealised past, but to its faults. He embraces the endless pull to return to what has been escaped, driven by experience, imagination and a productive, gnostic nostalgia as his own recollections dim and move further from experience. These paintings suggest a familiar discontent that transcends their West Midlands setting. Shaw's work offers no false, shiny future; his is a depressed Britain, as described by Morrissey, Philip Larkin and Alan Bennett. His paintings are not depictions of the world; they are the world. They are not screens on to which judgements about the state of things can be projected, but instead hold within themselves an engagement with and deep understanding of place.
LLF

Study for 'Your End', 2010

The Next Big Thing, 2010

Overleaf
The Blocked Drain, 2010

Wolfgang Tillmans

An abstract dense green photograph by Wolfgang Tillmans, *Freischwimmer 155* (2010, pp. 160–61), stretches along a wall like an endless moving cloud of vapour. The image could well be an illustration of the life-enhancing green gas described by H.G. Wells in his novel *In the Days of the Comet*, from which this exhibition takes its subtitle: 'The sky was streaked with bright green trails. They radiated from a point halfway between the western horizon and the zenith, and within the shining clouds of the meteor a streaming movement had begun, so that it seemed to be pouring both westwardly and back toward the east, with a crackling sound, as though the whole heaven was stippled over with phantom pistol-shots.' Unimpeded by the conventions of image-making, in this *Freischwimmer* (literally, 'free swimmer') series, produced without a camera, Tillmans creates fields of shifting colour and texture to address the materiality of photography, directly manipulating light onto photographic paper.

Methods of producing and displaying images are central to Tillmans' methodology: he unpacks the image as both subject and object, unfolding the ways in which light, paper and chemicals enable the photographic process to capture fragments of the present. His 'paper drop' works, for example, take the form of photographs of rolled sheets of paper; in these image-sculptures the photograph is both image-maker and image-object. The *Lighter* series, too, works with the photograph as object, presenting buckled and folded photographic paper in Plexiglas boxes. Both sequences point to the alchemy involved in the processes of photography. By using paper to hold light, partial versions of the surrounding world are produced that come to define interpretations of how we make sense of what surrounds us.

Tillmans uses photography to identify a space between doubt and belief, pointing to the dangers of claims on truth, and exploring how culture and history develop from systems of received knowledge. His work proposes that images are as capable of constructing the surrounding world as they are of depicting it. He pays particular attention to the display of his works, creating constellations of images to interrogate the ways in which pictures build the assumptions that influence both our conduct and understanding. People, places, meetings, traces of events, light falling and astronomical observations are some of the moments that Tillmans' camera freeze-frames, with these captured instants often returning in different formats and scales. In a formal and conceptual examination of the image, his partisan eye asks for subjective attention to be tuned to looking rather than simply to seeing.

Alongside the image of swirling green, nine tables display a collection of printed matter and images. *Table A, Space, Food, Religion (TSC)* (2010, p. 159) consists of material gathered in Britain throughout 2010. A bunch of flowers sits next to a folded piece of fabric. An installation shot of monochrome works by Tillmans is placed beside the same image reproduced in a magazine review. Articles on the Vatican's attitudes to homosexuality lie next to news reports of gay teenagers being hung for crimes against Sharia Law. In *Table 3, Paradise, War, Religion, Work (TSC, New York)* (2007, pp. 160–61) a black-and-white photograph of the Pyramids precedes a *Newsweek* article on George Bush's re-election, followed by an IKEA advert, postage stamps, the question 'What's wrong with redistribution?', an *International Herald Tribune* report on voting scandals and a photograph of British social housing. These collages of photographed moments, advertising and newspaper clippings reveal a set of observations on the surrounding world, pause the present and, like *Freischwimmer 155*, question fixed structures of visual understanding. 'TSC' stands for 'Truth Study Centre', the overall title of this series of works, begun in 2005, which interrogate 'truth' as a contested story told by unreliable narrators. Changing according to the context of the location and to shifts in the particularities of the present, Tillmans' table works redefine history as a story built from approximations, miscommunications and missed possibilities.

LLF

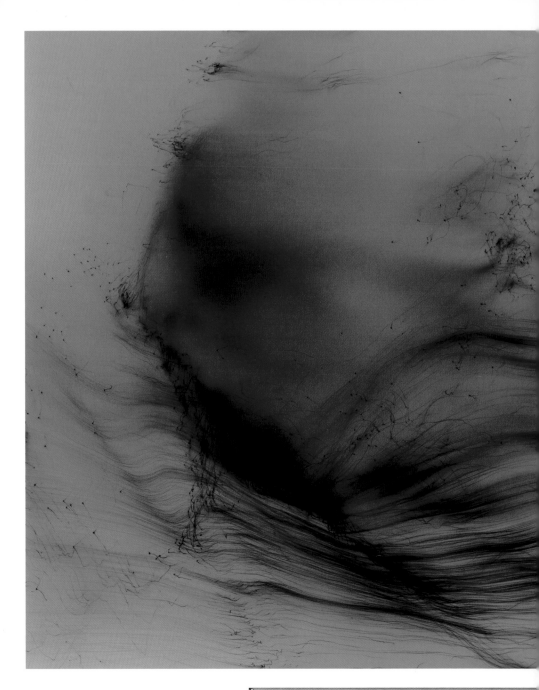

Previous page
*Table A, Space, Food, Religion
(TSC)*, 2010 (left); *Table 1, Truth Study Centre
(Hannover)*, 2006 (right)

Above
Freischwimmer 155, 2010

Right
*Table 3, Paradise, War, Religion, Work
(TSC, New York)*, 2007

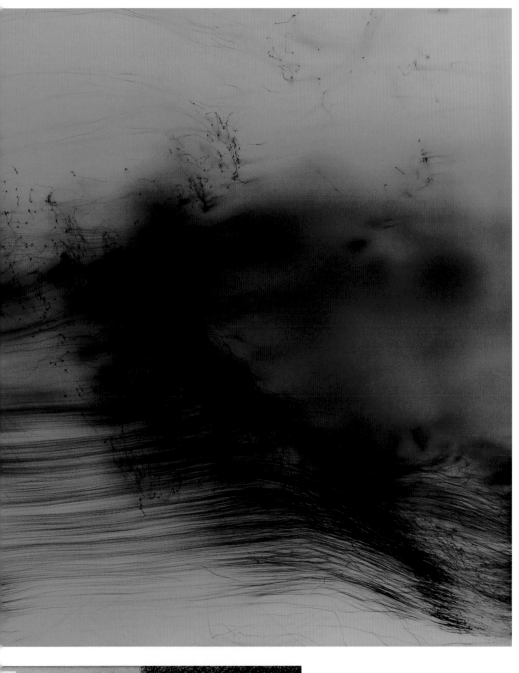

Sue Tompkins

Sue Tompkins uses language to form her artworks, constantly collating gatherings of words and phrases. In her performances and installations, all slivers of language are equally valued: high literature is as important as emotionally laden outbursts, casual observance as significant as philosophy. In each of the four cities hosting *BAS7* Tompkins presents a one-off performance entitled *Hallo Welcome To Keith Street*. Working with only a stool, a microphone and a ring-binder full of hundreds of meticulously ordered and edited texts, she reads out her material, using the live nature of the performance to 'energise my search to connect to others through language'.

Through pauses, stresses, elaborations and repetitions, Tompkins claims possession of the spaces within language, her non-linear narratives moving from one subject to another as quickly as thoughts do. Abstract ideas and perceptions become tangible: in the manner of concrete poetry, Tompkins releases words from their role as expressive carriers of meaning, making these communicative forms become objects. She uses her stool to prop open her notes while she paces her way through her references, speeding up and slowing down, constantly moving to give her words space to breathe. In the performance *Grease* (2006, pp. 163–65), for example, she delivered material collected over an eight month period, with her lines ranging from a torrent of x-es read out loud, to a skewing of the lyrics to the primary school hymn 'When I Needed a Neighbour'

shifting it from generic upbeat positivity to heartfelt melancholy. Intakes of breath, laughter and self-conscious checks on the audience's attention levels provide punctuation breaks. She stresses that 'I like looking at and feeling not so very separate from the audience. The isolation of performing offers a sort of flicker between empathy and understanding.' Her collages of words are emotionally charged and hypnotic, as looping waves of repetition tumble into rhythmic compositions, making meaning from collisions of words and phrases that do not normally sit together.

Tompkins describes her working process as extending out from an ever-expanding and fluid archive of 'thoughts, statements, views, descriptions, feelings, emotions and things that are triggered by actual events, feelings, sights and sounds […] often these are very literal visual descriptions that I try to put into words'. These become the material of Tompkins' performances and installations. This accumulation of perception fixed by language becomes a collection that is first simply held in the artist's memory, taking no tangible form. Mulling over relationships of words to the things and events to which they refer, she gradually isolates fragments to fix in written text. Sometimes the words are handwritten, sometimes phrases float on newsprint, having been roughly pushed through an analogue typewriter. Sometimes a single word is isolated on a folded and crumpled page; at other times it is repeated. In the series *Fashions* (2008), for example, statements such as 'let me in', 'what is it like to love historically?' or 'look at that sun/don't sink' are full of charged meanings, open to being personalised. Private emotions become public utterances, persuading those encountering Tompkins' avalanches of language to imagine, often against best intentions, for example, what it might feel like to look at a sun and will it not to disappear. John Cage advised that 'the world changes according to the place we place our attention. This process is addictive and energetic'. Through observation and emotional engagement Tompkins offers the same counsel as Cage: she captures the ways in which language both fixes and misrepresents experience, embracing failure and recalibrating where perception might be focused.

LLF

Above and overleaf
Grease, 2006

xxx.
xx.
xxx.
xx.
xx.
xx.
xx.
xxx.xx.
xxx.
xx.
xxx.
xxx.
xxx.
xxx.
xxx.
xxx.

xxxx.
xxx.
xxx.
xxx.
xxx.
xxxx.
xxxx.
xxx.
xxx.
xxx.
xxx.
xxx.
xxx.
xxx.
xxx.
xxxxxx.
xxx.
xxx.
xxx.

repeat

```
when i needed aneighbour where you there
were yiou there?

when i needed aneighbour were you there?
were you there/?
when i needed a  neighbour were you there?
when i need aneighbour were you there were yoy there?
when i nedd aneighbourwwere you there werte you there?
i neeeded aneighbour.
when i needed aneighbourwere you there were you there?
whdn i nededc a neighbour were younthere were you there
when i neddc a neighbour were you there were you there?
i neededed aneighbour.
when i neede aneighbour were you there were yopu there?
i needed aneighbour.
when i needed anew neighbour were yoiu there were you there?
when i neddecaneighbour were you there were you ythere?
i need aneighbour.
```

Phoebe Unwin

Phoebe Unwin has described the experience of looking at a painting as one that is 'physical, felt [...] and is in a sense always in the present'. It is fitting, then, that the motifs in her canvases are drawn from the proximate world – pigment-hazed domestic interiors and half-averted human faces, papers placed neatly on patterned desktops, and flower stems that seem not so much arranged as offhandedly plonked. This is the stuff of everyday life, and Unwin depicts it not so much out of a desire to elevate or poeticise the familiar, but to tune us into the kind of mental event that seems almost too fleeting and modest to be called a feeling or a thought. In her early work *Falling Sunglasses* (2007) a figure slouches on a beach towel, his sunglasses skidding down his patchily haired chest in the serial manner of a cartoon flip book. We're reminded of the smell of hot plastic slick with lotion, and the mild annoyance of the sun's sudden glare, of the discomfiture of losing our poise, and of witnessing awkwardness in others. Unwin offers us a reclining (near) nude, but this is neither an exercise in classicism nor a snook cocked at the history of her medium. Her paintings are not arguments, except perhaps for paying attention to small experiences in a big world.

Paint, in Unwin's canvases, often visibly becomes painting, while never quite being wholly subordinated to the business of representation. In her *Silver Shower* (2008) three thick passages of pigment sluice from a steely fitting, at once water and juicy, charcoal grey acrylic. Pattern is important in her work, not only in the sense of a decal duplicated for decorative effect, but also in the sense of the configuring of information. In *Aeroplane Meal* (2008) several visible layers of abstract, almost-but-not-quite-repetitious brushwork are built up, which are finally overlaid with a stencilled image of an airline meal tray, neatly compartmentalised to hold the passenger's cruet, drink and various dishes. The twin pleasures of the piece are in the creation of structure, and the formal possibilities that open up when structure begins to break down: Unwin's meal tray has a different number of compartments from its standard real-world counterpart, as though to playfully underline the fact that illogic and excess belong as much to the figurative as to the abstract register.

For all the painterly plenitude of Unwin's work, with its abundance of textures, colours and perspectival gambits, it often turns on the apparent concealing of information. When she paints people, they are nearly always solitary and only in partial view. A kind of existential shyness often seems to be in play, as in her *External Outline of a Thing (Head)* (2010), in which a woman's face is obliterated by creamy medium, or in *Man with Heavy Limbs* (2009, p. 167), in which a harlequin-like figure sits on a bench, his neatly pressed-together knees telling us everything we need to know about his introspective and nervy cast of mind, despite his face being 'out of shot'. In her recent canvas *Queue for Words* (2010, p. 169), we see what seems to be a sheet of lined writing paper, on which each scribbled phrase has been struck out with a thick oblong of correction fluid. This, though, is a representation, not the thing it represents, and if there were ever painted words on the painted page, they do not belong to the finished work. With characteristic wit, Unwin creates an image of absence from which nothing is missing, and an image of dissatisfaction that satisfies the criteria of its own being. We might also apply this description to her *Cinema* (2010, p. 168), in which the painted audience watches not a looping projection but a static picture they also inhabit. The emphasis here, as with all her works, is on what can be seen, what order of things it belongs to, and what kind of life it leads in the strange, familiar territories of our minds.

TM

Man with Heavy Limbs, 2009

Cinema, 2010

Queue for Words, 2010

Tris Vonna-Michell

Tris Vonna-Michell's performances are rapidly delivered monologues that take place in dimly lit mixed-media installations. His narratives, addressed to one or more people for a period of time often set by the listener and monitored by an egg timer, fuse elements from his personal life with history and fiction. The fractured stream-of-consciousness diversions that invade and blend seamlessly into his gabbled stories, driving them to near incomprehensibility, contribute to future performances of the same work, so that it remains in a state of constant evolution. No two performances are ever the same; as the artist has explained: 'It's impossible to narrate consistently.' Documents and images used in the performance – hand-written and photocopied pages, 35mm slides and found objects – form a web of associations, which are picked up and dropped, repeatedly recycled from show to show. Subjecting himself to the testing processes of memory and the immediacy of performance under the pressure of time, Vonna-Michell describes the experience as: 'acceleration, adrenaline, both inducing a transformation of materiality into something visceral, inconsistent, and aloof from an intended meaning'.

Trips made by the artist often feature as part of the metaphorical journey on which his audience is taken. The ongoing work *hahn/huhn* (begun 2003) rotates around the story of Reinhold Huhn, a 21-year old East German border guard, shot dead by a West Berlin escape agent on 18 June 1962. A monument erected to Huhn at the place where he was shot, which mistakenly cites his name as Hahn, drew Vonna-Michell to Berlin, on a search for evidence of this man, who was one of many guards controlling the underground tunnels in the Anhalter Bahnhof (a now disused railway station), linking East to West Berlin. All that he found was 'a kiosk in a grit-gravelled car park'. The fat headless plastic chicken that balances over the kiosk adds to the multiple references in the title, which translates from the German as *Rooster/Hen*.

The installation *Seizure* (pp. 172–73), which derives from a 2007–8 performance of *hahn/huhn*, juxtaposes a slide of the kiosk with a large image of a plastic archival box, pointing to the notion of the archive that underpins many of Vonna-Michell's narratives. A project entitled *Leipzig Calendar Works* (begun 2005) took as its origin the painstaking reconstruction by a group of 'puzzlers' of Stasi archives from millions of hand-torn fragments that had evaded the electric shredder and furnace during the last days of the GDR. Vonna-Michell transported his archive of childhood photographs to a *Plattenbau* – a GDR prefab towerblock – bedroom in Leipzig, where for a whole month he shredded these documents of his past and glued them in new configurations onto three calendars. Such works suggest the multiple ways in which history, through webs of fluid memories and fragmentary evidence, tells and hides, constructs and ultimately fictionalises. EM

Emily Wardill

Drawing on everything from the thought of John Ruskin and Jacques Rancière to medieval stained glass windows and the Nintendo Wii, Emily Wardill's sensous, highly elliptical films insist on the ungovernable strangeness of images. Deeply concerned with the structure of language (visual, verbal, cinematic, musical), they are threaded through with coded clues that play upon our expectation that a settled interpretation might be arrived at. Such leads, though, are perhaps not to be trusted – for Wardill what's important is not a narrative destination, but the process of seduction by which she draws the viewer in to her intense and opaque filmic worlds.

Shown together at Wardill's request, *Sea Oak* (2008) and *The Diamond (Descartes's Daughter)* (2008, pp. 176–77) both turn on absence and the instability of representation. Based on a short story by the American writer George Saunders, *Sea Oak*'s only 'image' is 51 minutes of blackness, thrown from leader running through an illuminated 16mm film projector which plays a soundtrack of interviews the artist conducted with members of the left-leading Californian think tank The Rockridge Institute, who have researched the use of metaphor in neo-conservative political rhetoric. Here, the film's lack of visual material highlights the broader disconnect (endemic in contemporary capitalist culture) between words and the things they represent. As Wardill has said, 'I realised after I had shot the footage that the film had to have no image, because if it had an image I would be completely undoing everything I was talking about'. In a formal reference, perhaps, to *Sea Oak*'s spot-lit projector, *The Diamond (Descartes's Daughter)* opens with an image of a dark room, strafed by thin beams of green light. What follows is an interweaving of the mythic tale of the philosopher René Descartes' construction of an automaton modelled on his dead daughter, with an account of the artist's attempt to recreate a half-remembered scene from a heist movie featuring a diamond protected by lasers. Shot through with references to history, philosophy and cinema, the film is perhaps best understood as a restless meditation on how cognition and, more specifically, the process of remembering and remaking the vanished past, is as much an act of imaginative speculation as dreaming up the days to come.

Making use of the dramatic schema of Pedro Calderón de la Barca's 1635 play *La Vida es Sueño* (Life is a Dream), Wardill's feature-length film *Game Keepers Without Game* (2009, p. 175) relocates the Spanish playwright's story of prodigal children and patricide to contemporary London. Here, a bourgeois father (described as a writer 'interested in hybridity') attempts to integrate his schizophrenic teenage daughter back into the family home, having put her into care some nine years previously. Her anger, which builds like Wardill's sparse, percussive soundtrack, seems as much the result of her steep descent down the class ladder during her absence than her abandonment by her parent – exquisitely shot still lives of artworks, expensive furniture, design classics and books break up the starkly minimal set; part props, part status symbols that the girl can't possibly understand, part clues in an unravelling murder mystery. As the film spools on, fragments of dialogue, from empty chatter to reflections on the writing process, are spoken and seem to hang listlessly in the white space of the set, never quite reaching resolution. Narrators stumble over and then correct their own over-dubbed lines. Communication seems always doomed to failure. *Game Keepers Without Game* concludes with the girl's murder of her father with an axe, the only moment in the film that we see an object and a human body physically meet – Wardill has said she wanted to shoot the work 'like airline food, so you have this sense that everything is separate and nothing ever touches. At the end when [the daughter] murders the father, you're as shocked to see [...] this axe touching his head, as you are that he's died'. Like all of her films, *Gamekeepers…* is, in the end, about connection, and how the logics with which we customarily structure our lives are inadequate in the face of the wonder, horror and vivid oddity of the world, and the ways in which we process it in the editing suites of our minds.

TM

Game Keepers Without Game, 2009

Overleaf
The Diamond
(Descartes's Daughter), 2008

Keith Wilson

Since the late 1990s, Keith Wilson has developed a family of galvanised steel structures that recall spaces in which bodies and abstract ideas are organised and channelled, from the abattoir to the stadium, from the periodic table to the hopscotch grid. Echoing the utilitarian forms of farmyard gates, fences and holding pens (with their offhand weld-jobs and drill-holes, their brusque planes and bends), each of these works seems to insist on a particular methodology – *this* is the only way we should walk, or *that* is the only way that information should be sequenced. Wilson, though, is not interested in enforcing rules, but rather in pointing to their often arbitrary nature, and inviting the viewer to circumvent them through his or her particular perversity of mind.

Ziggurat (2010, pp. 180–81) takes the shape of a stepped pyramidal tower, constructed from 61 cubic units. Inside 26 of these stands a sculpture that corresponds to a letter of the alphabet, supported by a base plate made from a wooden blackboard. Despite the atmosphere of pedagogy that these blackboards provide, Wilson's lexicon – which includes a drift of dishwasher salt, a waxy ball of sheep's wool and three grubby plastic sprockets stacked like Constantin Brancusi's *Endless Column* (1938) – suggests no logical relationship between a given letter and a given object; indeed, with a little imagination and linguistic flair, one could argue that each of these sculptures represents 'A' or 'Z' or any alphabetical point in between. *Ziggurat* indicates – like a 'certain Chinese encyclopaedia' famously cited by Jorge Luis Borges in his 1942 essay 'The Analytical Language of John Wilkins', which categorises animals according to whether they are embalmed, belong to the Emperor, or have just broken a

vase – that the taxonomic systems we employ are historically and culturally specific, and that other systems might serve as well or better in the filtering of the raw stuff of life.

Formed from the same cubic units as *Ziggurat*, Wilson's 12-part sculpture *Calendar* (2010) replicates the calendar grid of each month in 2011 as it might appear on a wall chart, computer or mobile-phone screen. Here and there in these shelf-like constructions, a unit will house a sculpture (usually made from found objects), and we are invited to speculate on its relationship to a particular 24 hours. When the piece is on show during 2011, these temporal periods will include both days past and days to come, days of private commemoration and of public celebration, days in which too little happens for some, and much too much happens for others. None of the sculptures in *Calendar*, of course, can hope to sum up the totality of human experience on a given date (might they in fact make a worse fist of this than the empty units?), but they nevertheless make their oblique stabs at meaning something to someone, somewhere. What other option do they have? As Philip Larkin observed in his poem 'Days' (1953): 'Days are where we live [...] Where can we live but days?'

Commissioned by Transport for London for the ticket hall of Hammersmith Underground Station (although it has not yet been exhibited there), Wilson's *Zone 1* (2010–11, p. 179) is a snaking, galvanised steel walkway that replicates a central portion of the Piccadilly line, as depicted on Harry Beck's classic London Tube map. With its interior panels lacquered in 'Piccadilly line blue', the sculpture resembles both a corridor from a spaceship dreamt up by a Hollywood set designer, and the narrow structures through which cattle are led to the slaughter in meat-processing plants. Installed in public spaces outside a number of *BAS7*'s venues, *Zone 1* operates as a stray and illogical piece of transport infrastructure. Visitors who choose to walk through Wilson's sculpture must negotiate several kinks and angles produced by Beck's supposedly supremely rational design. With characteristic humour, the artist demonstrates that even an idea as simple as getting from A to B and back again is rarely as straightforward as it might seem.
TM

Ziggurat, 2010 (detail)

Zone 1, 2010–11

Overleaf

Ziggurat, 2010

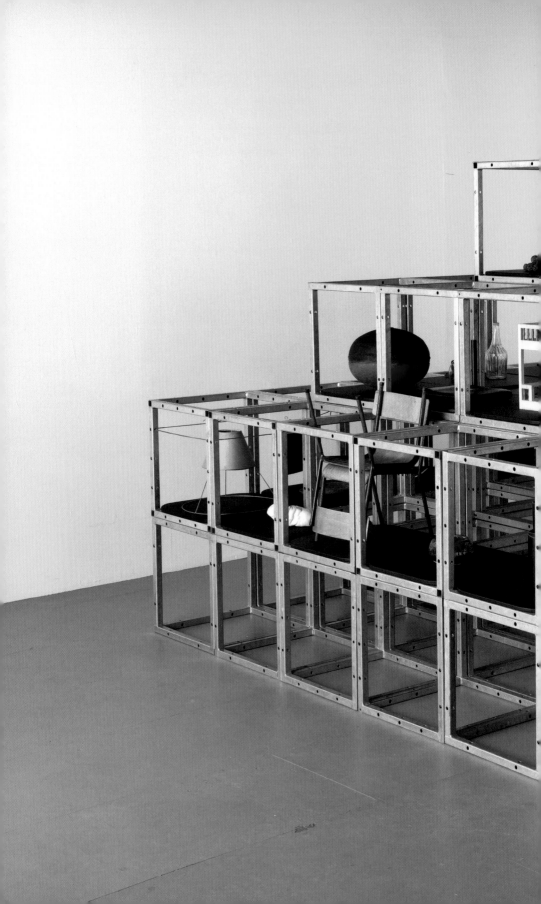

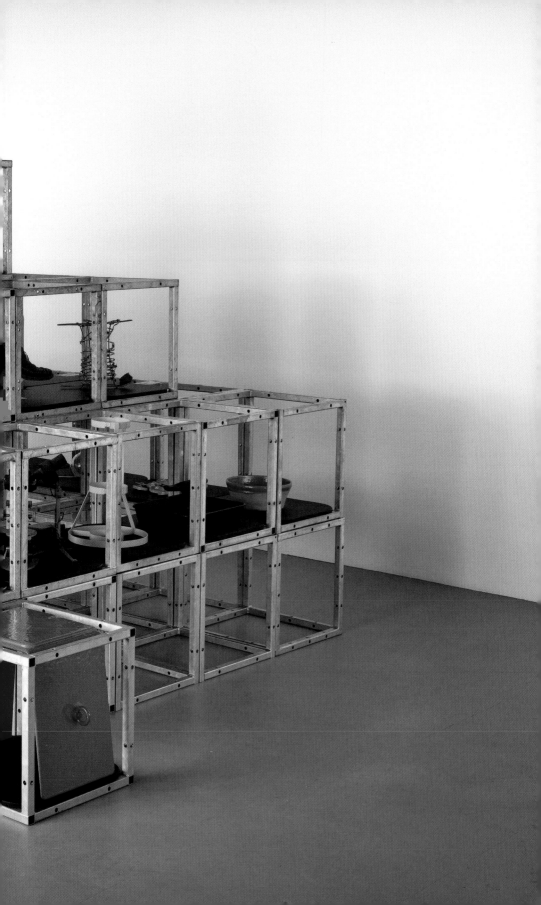

List of Exhibited Works

British Art Show 7: In the Days of the Comet is an evolving exhibition with each episode introducing new works in changing displays. The selection will evolve during the show's year-long duration. Where known, works that will be exhibited at particular venues are indicated.

Dimensions are given in centimetres, height before width and depth. Unless otherwise stated, works are © the artists and the images have been supplied by the artists or their representatives.

Works marked with an asterisk (*) are illustrated in the catalogue. For works that are reproduced but not exhibited, see pp. 186–87.

Charles Avery

Untitled (Miss Miss finally gives in by the tree where Aeaen sought to bamboozle the One-Armed Snake by attaching himself to the tree to make himself a larger thing), 2010
Mixed media sculpture
485 × 421 × 322
Courtesy of Pilar Corrias Gallery
Untitled (The Bar of the Egg Eating Egret), 2010
Pencil, ink and gouache on paper
163.4 × 121.8
Courtesy of Pilar Corrias Gallery
Nottingham only
Untitled (Place de la Revolution), 2010
Pencil, ink and gouache on paper
210 × 340
Courtesy of doggerfisher
London, Glasgow and Plymouth only

Becky Beasley

KORREKTUR (North Northwesterly) (And where, I asked myself, did Höller get the idea for this house of his, because I am fully aware that I got my idea, to build the Cone for my sister, from Höller and his house at the Aurach gorge. – Thomas Bernhard), 2010
KORREKTUR (West Northwesterly) (Possibly Höller doesn't even know where he got the idea for building his house and for building it as he ended up building it, a house so much in accordance with himself, as I've never seen another. – Thomas Bernhard), 2010

KORREKTUR (Southwesterly) (I'll ask him where he got his idea, I thought, and I asked Höller where he'd gotten his idea, because I simply had to know, while I looked over and studied and explored his house, it was indispensable for me to know. – Thomas Bernhard), 2010
KORREKTUR (South Southeasterly) (But Höller can't remember where he got the idea to build his house. The chances are that the house that gave Höller the idea to build his own house is standing quite close by, I thought, as close as can be to the Höller house. – Thomas Bernhard), 2010
KORREKTUR (South Easterly) (Yet there's no other house to compare with it, I thought, so Roithamer. It's also possible that Höller never saw the model for his house in reality, for in reality there isn't any model for Höller's house in the vicinity, I thought, so Roithamer, it must have come to him in a dream. – Thomas Bernhard), 2010*
KORREKTUR (East Northeasterly) (In that case it's quite likely, I thought, that Höller didn't see a model of the house in a dream, but that he dreamed the house Höller. All he had to do was trust his dream and accurately copy the house he saw in his dream, so Roithamer. – Thomas Bernhard), 2010*
KORREKTUR (Northeasterly) (Since he's a master of the craft and in addition drew on all sorts of books, as I know, including the kind of books I myself got hold of for my own purposes, for the rest of building knowledge he needed, it was only a question of willpower and endurance for Höller to be able to build his house. – Thomas Bernhard), 2010*
Series of 7, b/w inkjet on Hahnemühle photo rag 310gsm paper using archival inks, pale yellow acrylic glass, each 109 × 130
Courtesy Laura Bartlett Gallery, London

Karla Black

Brains Are Really Everything, 2010
Soil, paint, glue, plaster powder, powder paint, soap
400 × 400 × 80 (approx)
There Can Be No Arguments, 2010
Polythene, plaster powder, powder paint, thread
350 × 200 × 180 (approx)
All works courtesy the artist; Mary Mary, Glasgow; Galerie Gisela Capitain, Cologne

Juliette Blightman

The formula is familiar, too quickly and too easily employed. It would not be a bad idea, in this case, as in others, to consider it from the vantage point of time, which is a convenient position when one finds oneself in the uncomfortable situation of having to judge an object so close at hand and so unusual that it tends to blind you., 2010
Vase, picture, light
Dimensions variable
Courtesy of the artist and Hotel, London
Nottingham only

Varda Caivano

Untitled, 2009, 46 × 61*
Untitled, 2010, 61 × 45.5*
Untitled, 2010, 65 × 41
Untitled, 2010, 70 × 50.5*
Untitled, 2010, 90.5 × 75
Untitled, 2010, 97 × 66.5
All works are oil on canvas and courtesy the artist and Victoria Miro Gallery, London
Photos: Stephen White

Duncan Campbell

Bernadette, 2008*
Single screen standard definition video with stereo audio
37 minutes, 10 seconds
Video for projection
Courtesy the artist and Hotel, London
Images on p. 48 (top, bottom)
© Christian Simonpietri/ Sygma/Corbis

Spartacus Chetwynd

The Folding House, 2010*
Wood, steel, aluminium, glass
400 × 300 × 300
Courtesy Sadie Coles HQ, London

Steven Claydon

From under the periodic table. ARGON, 2010
Polyurethane foam, pigment, cast aluminium, steel, powder-coated steel, 190 × 60 × 70
From under the periodic table. GASSY MIXTURES, 2010
Polyurethane foam, pigment, cast aluminium, steel, powder-coated steel, 190 × 60 × 70

JOANNA (An Unsubstantial Fraction) (Of Substance Without Action), 2010
Lacquered wood, portable keyboard keys, buckram, powder-coated steel, cement, peacock 'hair', wood, brass, leather, polyester resin, 200 × 130 × 130
All works courtesy the artist and Hotel, London

Cullinan Richards

Collapse into abstract (black), 2008
Floor paint on wood, 136.5 × 162.5
The Breakdown, 2010*
Creative Sterility traps England in a wasteland of ambition, 2010*
Diego Maradona for offensive comments and gestures, 2010*
Prints on glassine paper, each 75 × 51
Collapse into abstract (white), 2010*
Oil and floor paint on wood, newspaper, black sticks, plastic display mount, 136.5 × 162.5 × 2
Large Chandelier (suspended from the floor, seen from above), 2010*
Box transformer, painted plastic, plastic, scaffolding, argon (neon), glass rods, 230 × 120 × 120
Paula Radcliffe in a disappointing fourth place, 2010
Oil paint on canvas, rubberized paint on glassine paper, 71 × 47 × 2.5
Steve, 2010
Grey professional floor paint, paint tin, newspaper, 100 × 65 × 30
Twenty rolls of tape, 2010*
Foil, emergency and masking tapes Dimensions variable
Vertical Realism Lamps, 2010*
T5 fluorescent bulbs, wood, gloss paint, emergency cord, 80 × 60 × 40
All works courtesy the artists

Matthew Darbyshire

An Exhibition for Modern Living, 2010
Mixed media, 250 × 360 × 450
Courtesy Herald St, London

Milena Dragicevic

Supplicant -13, 2008*
Oil on linen, 61 × 56.5
Private Collection, Sterzing
Supplicant 77, 2008*
Oil on linen, 61 × 51
Courtesy Galerie Martin Janda, Vienna
Supplicant 00, 2009*
Oil on linen, 61 × 51
Courtesy Galerie Martin Janda, Vienna

Supplicant 202, 2009
Oil on linen, 61 × 51
Arts Council Collection, Southbank Centre, London
Supplicant 408, 2009
Oil on linen, 61 × 56.5
Private Collection, Prague
Supplicant 309, 2009*
Oil on linen, 61 × 56.5
Private Collection, New York

Luke Fowler

Composition for Flutter Screen, 2008 (with Toshiya Tsunoda)*
Fabric screen, fans, spotlights, amplifiers, contact mics, speakers, vibration motor, steel wire, switching box, 16mm film
Dimensions variable
Produced by Yokohama Triennale
Courtesy The Modern Institute, Glasgow
Photo: Veno Norihiro
Distributed by LUX
Glasgow and Plymouth only
A Grammar for Listening (parts 1–3), 2009*
16mm film, parts 1 and 3 – separate sound file, part 2 sound (optical)
Part 1: 22 minutes
Part 2: 21 minutes
Part 3: 13 minutes
Courtesy the artist and the Modern Institute, Glasgow
Photos: Ruth Clark
Distributed by LUX
Nottingham and London only

Michael Fullerton

Carl Jung, 2006
Oil on linen, 61 × 46
Private Collection
Seminal Event Repeated, 2007*
Oil on linen, 182 × 100
Courtesy the artist and Carl Freedman Gallery, London
Seminal Event (Vidal Sassoon Corp. Executive Board 1968), 2007
Silkscreen on newsprint, each 75 × 100
Courtesy the artist and Carl Freedman Gallery London
Catherine Graham, 2008*
Oil on linen, 61 × 46
Courtesy the artist and Carl Freedman Gallery, London
Tatiana Romanov, 2008
Colour study of the painting 'Elizabeth Foster' (1787) by Sir Joshua Reynolds (Leon Trotsky version), 2008*
Oil on linen, each 61 × 46
Courtesy the artist and Carl Freedman Gallery, London

Alasdair Gray

Blue Denim Christine and Dan Healey, Rex Scortorum, 2008
Acrylic, ink, pen and pencil on board, 52 × 61
Mick Broderick, 2008
Acrylic, oil, pencil and watercolour on board, 100 × 60
Alasdair and Ann Hopkins, 2009
Ink, acrylic and oil on paper 48.2 × 69.8
Andrew Gray Aged 7 and Inge's Patchwork Quilt, 2009*
Pen on brown paper tinted with acrylic and oil on board, 49 × 63
Teacher, Historian, Poet, Angus Calder, 2009
Ink drawing tinted with acrylic, crayon and oil, 41.5 × 64.5
May in Black Dress on Armchair, 2010*
Ink drawing on brown paper, acrylic background, 79.5 × 49.4
May on Invisible Armchair, 2010
Ink drawing on brown paper, acrylic background, 68.7 × 46.1
All works courtesy the artist and Sorcha Dallas, Glasgow
Photos: Ruth Clark.

Brian Griffiths

The Body and Ground (Or Your Clumsy Hands), 2010
Canvas and mixed media
Dimensions variable
Courtesy the artist and Vilma Gold, London
London, Glasgow and Plymouth only
The Body and Ground (Or Your Lovely Smile), 2010*
Canvas, scenic paint, ropes, webbing (various), fibre glass poles, plastic poles, vintage travel souvenir patches, net fabric, tauperlin, duck tape, thread, string, concrete blocks, fixings 350 × 580 × 450
Courtesy the artist and Vilma Gold, London
Nottingham, Glasgow and Plymouth only

Roger Hiorns

Untitled, 2005-10
Bench, fire and youth
Dimensions variable
Courtesy Corvi-Mora
Nottingham only

Ian Kiaer

Melnikov project, silver, 2010
Mixed media, dimensions variable
Courtesy the artist and Alison
Jacques Gallery, London

Anja Kirschner and David Panos

The Last Days of Jack Sheppard, 2009
High Definition Video, 56 minutes
Images courtesy the artists and
Hollybush Gardens, London
Nottingham only
The Empty Plan, 2010*
High Definition video
90 minutes (approx)
Funded by Arts Council England
through Film London Artists'
Moving Image Network,
co-produced with City Projects
and supported by Focal Point
Gallery, Staatsgallerie Stuttgart
and Kunsthall Oslo
Images courtesy of the artists and
Hollybush Gardens
London, Glasgow and Plymouth only

Sarah Lucas

NUD CYCLADIC 3, 2010*
Tights, fluff, wire
Sculpture: 43 × 50 × 41
Plinth: 142 × 42.8 × 42.8
NUD CYCLADIC 5, 2010
Tights, fluff, wire
Sculpture: 53 × 49 × 43
Plinth: 142 × 42.8 × 42.8
NUD CYCLADIC 6, 2010*
Tights, fluff, wire
Sculpture: 43 × 46 × 38
Plinth: 102 × 42.8 × 42.8
NUD CYCLADIC 10, 2010*
Tights, fluff, wire
Sculpture: 41 × 41 × 35
Plinth: 102 × 42.8 × 42.8
NUD CYCLADIC 16, 2010
Tights, fluff, wire
Sculpture: 30 × 49 × 33
Plinth: 86 × 43 × 43
All works courtesy Sadie Coles HQ,
London
Photos: Julian Simmons

Christian Marclay

The Clock, 2010*
Single channel video, 24 hours
Courtesy White Cube
*Nottingham, Glasgow and Plymouth
only*

Simon Martin

Seated figure (692)
Seated figure. Central America,
Mexico Veracruz:
Olmec Style. Early formative
period (1200–900 BC)
Gray basalt, traces of red pigment
or soil, 51.8 × 25 × 14.3
Acquired 1977
Robert and Lisa Sainsbury
collection
UAE 692
Untitled (After Sol Le Witt), 2010*
Five Pigment prints
Frame: 48.8 × 56.5
Image: 17 × 33.8
Untitled, 2010*
Digital animation, Hantarax
Monitors, Unicol stands,
DVD players
Dimensions variable
All works courtesy the artist
Photos: Ellen Page Wilson

Nathaniel Mellors

Ourhouse, 2010*
High Definition video and anima-
tronic sculpture, 35 minutes
Courtesy the artist, Matt's Gallery,
London, MONITOR, Rome, Diana
Stigter, Amsterdam and Lombard-
Freid Projects, New York
Ourhouse was commissioned by
De Hallen Haarlem and British Art
Show 7 with the financial support
of the Netherlands Film Fund and
the Netherlands Fund for Visual
Arts, Design and Architecture

Haroon Mirza

Regaining a Degree of Control, 2010
Mixed media, dimensions variable
Courtesy the artist and Lisson
Gallery, London

David Noonan

Untitled (Tapestry), 2010
(produced with the Australian
Tapestry Workshop)*
Tapestry, 230 × 292
Tapestry Foundation of Victoria
Weavers: Sue Batten, Amy Cornall,
Cheryl Thornton

The Otolith Group

Otolith I, 2003*
Film, colour with sound
22 minutes, 16 seconds
Otolith II, 2007*
Film, colour with sound
47 minutes, 42 seconds

Otolith III, 2009*
High Definition video, colour
with sound, 48 minutes
All works courtesy of The Otolith
Group and LUX, London

Mick Peter

*It Seems The Peacefuls Have Stopped
The War*, 2005
Ink on paper, 42 × 30
Leave the Little Tree, 2005
Ink on paper, 30 × 40
Private Collection
Two Clerks, 2006
Spray paint and ink on paper,
47 × 58
Untitled, 2006
Spray paint and ink on paper,
47 × 58
Pecuchet, 2007
Ink and pencil on paper, 30 × 42
Untitled, 2007
Spray paint and ink on paper,
45 × 36
Moldenke Fiddles On, 2008–9*
Jesmonite, wood, tubing, varnish,
each 168 × 152 × 70
Talbot's Room, 2009
Ink and pencil on paper, 54 × 34
London, Glasgow and Plymouth only
Untitled (Birds), 2009
Ink and pencil on paper, 55 × 37
Untitled (Stile), 2009
Ink and pencil on paper, 55 × 35
Frieze Satire Drawing, 2010
Ink on paper, 16 × 24.5
Wall Relief With Terracotta Chad,
2010*
Ink and pencil on paper, 40 × 30
All works except *Leave the Little Tree*
courtesy of the artist and Galerie
Crèvecoeur, Paris

Gail Pickering

Sixty Six Signs Of Neon, 2010–11
Performance and live transmission
Courtesy the artist

Olivia Plender

The Lost Works of Johan Riding, 2010
Performance and mixed-media
installation
Dimensions variable

Elizabeth Price

User Group Disco, 2009*
High Definition video, colour,
sound, 15 minutes
Courtesy the artist and MOT
International, London

Karin Ruggaber

Relief #90, 2010*
Concrete, plaster, pigment,
spray paint, bark, 166 × 418 × 4.5
Courtesy the artist and
greengrassi, London

Edgar Schmitz

To Go with the Comet, 2010/11*
Various materials
Courtesy the artist and
FormContent, London

Maaike Schoorel

Painter in the Studio, 2010
Oil on canvas, 195 × 146
Private Collection, Ghent.
Courtesy Maureen Paley, London
and Galerie Diana Sigter,
Amsterdam
Self-Portrait in Black, 2010*
Oil on canvas, 45 × 35
Collection Soonieus,
The Netherlands. Courtesy
Maureen Paley, London and
Galerie Diana Sigter, Amsterdam
*Self-Portrait Reclining in the Tuscan
landscape*, 2010
Oil on canvas, 145 × 180
Private Collection, The
Netherlands. Courtesy Maureen
Paley, London and Galerie Diana
Sigter, Amsterdam
Self-Portrait Sitting in the Bathtub,
2010
Oil on canvas, 60 × 85
Courtesy Maureen Paley, London
Self-Portrait Sitting on a Chair, 2010
Oil on canvas, 135 × 95
Collection Thaddaeus Ropac, Paris
– Salzburg. Courtesy Maureen
Paley, London and Galerie Diana
Sigter, Amsterdam

George Shaw

The Blocked Drain, 2010*
The Next Big Thing, 2010*
Your End, 2010
Humbrol enamel on board,
each 147.5 × 198
Courtesy Wilkinson Gallery, London

Wolfgang Tillmans

Freischwimmer 155, 2010*
Inkjet print, 258 × 462
Courtesy the artist and
Maureen Paley, London
Truth Study Centre (BAS), 2010
Wood, glass, mixed media
570 × 620 (approximate installation
dimension)
Courtesy the artist and
Maureen Paley, London

Sue Tompkins

Hallo Welcome To Keith Street, 2010
Performance, duration varies
Courtesy the artist and Modern
Institute, Glasgow

Phoebe Unwin

Aeroplane Meal, 2008
Spray paint and oil on linen
97.5 × 107.5
Private Collection,
The Netherlands
Silver Shower, 2008
Acrylic and aluminium leaf on
linen, 145 × 121
Collection of Wilfried & Yannicke
Cooreman – De Smedt
Man with Heavy Limbs, 2009
Acrylic, Indian ink, charcoal and
pastel on glossy card and printed
paper, 146.5 × 100
TATE: Presented by Tate Members
2010
*London, Glasgow, and Plymouth
only*
Cinema, 2010*
Acrylic, graphite and household
paint on canvas, 51 × 40.5
Julian & Victoria Martin
External Outline of a Thing (Head),
2010
Oil, thixotropic alkyd medium
and spray paint on canvas
60.5 × 50.5
Private Collection
Queue for Words, 2010*
Oil, pastel ground and pigment on
canvas, 80.5 × 70.5
John and Odile Connolly, London

Tris Vonna-Michell

Balustrade, 2011
Performance, duration varies
Nottingham only

Emily Wardill

SEA OAK, 2008
16mm film and spotlight,
51 minutes
London only
The Diamond (Descartes's Daughter),
2008*
16mm film, 10 minutes
Game Keepers without Game, 2009
16mm film transferred to digital
file, 72 minutes
Supported by The Arts Council,
de Appel, University of the Arts
London and STANDARD (OSLO)
Nottingham only
All works courtesy the artist,
Jonathan Viner Gallery, London
and LUX

Keith Wilson

Ziggurat, 2010*
Galvanised steel and mixed media
203 × 254 × 304
Courtesy of the artist
Nottingham only
Zone 1, 2010–11 (2007)*
Hot-dipped and cold-rolled
galvanised steel, PU elastomer
178 × 92 × 1480.6
Commissioned by Art on the
Underground, 2006
London and Plymouth only
Photos: Dave Morgan

Works Illustrated but not Exhibited

Dimensions are given in centimetres, height before width and depth. Unless otherwise stated, works are © the artists and the images have been supplied by the artists or their representatives.

For a list of exhibited works, see pp. 182–5.

Charles Avery

Untitled (the grass is alive) triptych, 2007 (detail)
Ink and pencil on card
309 × 104
Courtesy of the artist and Galerie Arquebuse
Untitled (View of the Port at Onomatopoeia), 2009–10
Pencil and ink on paper
240 × 510
Courtesy the artist and Pilar Corrias Gallery, London
Photo: Andy Keate

Karla Black

Named and Gated, 2009
Polythene, chalk dust, thread
234 × 603 × 70
Courtesy the artist and Pilar Corrias Gallery, London
Photo: Andy Keate
Left Right Left Right, 2009
Dirt, spray paint, plaster powder, powder paint
20 × 531 × 345
Courtesy the artist; Mary Mary, Glasgow; Galerie Gisela Capitain, Cologne; Inverleith House, Edinburgh
Photo: Ruth Clark
Left Right Left Right, 2010
Compost, top soil, red building sand, golden hoggin gravel, hairspray, polystyrene, spray paint
305 × 460 × 83
Courtesy the artist; Mary Mary, Glasgow; Galerie Gisela Capitain, Cologne; Kunsthalle Nürnberg
Photo: Annette Kradisch

Juliette Blightman

Mirrors would do well to reflect more before sending back images, 2009
Chair on loan from Dirk Bell, mirror on loan from Heather and Adam
Dimensions variable
Courtesy the artist and Hotel, London
Photo: Guy Archard
The world is not my home, 2010
Chair, rug, window, brazier, fire, paint, song
Dimensions variable
Courtesy Jacopo Menzani
The day grew darker still, 2010
Chair, rug, table, light, nasturtiums
Dimensions variable
Courtesy the artist and Hotel, London
Please water the plant and feed the fish, 2008
Plant, tile, apple, goldfish bowl and stand
Dimensions variable
Courtesy of ICA, London
Photo: Stephen White

Duncan Campbell

Make it New John, 2009
Video for projection
50 minutes
Courtesy the artist and Hotel, London

Spartacus Chetwynd

The Walk to Dover, 2005
Courtesy the artist
The Fall of Man, 2006
Plumbing pipe, paper, cloth, tape
50 × 150 × 80
Courtesy the artist

Steven Claydon

The Ancient Set, 2008
Video for projection
7 minutes, 56 seconds
Courtesy the artist and Hotel, London
Installation shot containing *The Egotism of Exile*, 2009 (left); *Atop the Loam (A Forester)*, 2009 (right)
Courtesy the artist and Hotel, London

Matthew Darbyshire

Blades House, 2008
Mixed media
Dimensions variable
Photo: Matthew Booth

Funhouse, 2009
Mixed media
Dimensions variable
Photo: Tom Morton
ELIS, 2010
Digital print on dibond, wood, paint, light fittings, 5000 × 244
Photo: Andy Keate
All courtesy the artist and Herald Street, London

Brian Griffiths

To the Wonder and Satisfaction of All People, 2005
Balsa wood, various hard wood, paint, varnish, tin, cardboard
112 × 20 × 25
Courtesy of the artist and Galeria Luisa Strina
Life is a Laugh, 2007
Gloucester Road underground station, Art on the Underground
Dimensions variable
Courtesy the artist, Vilma Gold and Art on the Underground
Photo: Andy Keate

Roger Hiorns

Untitled, 2008
Stainless steel, brain matter
63 × 63 × 4
Courtesy the artist and Corvi-Mora, London
Photo: Marcus Leith, London
Untitled (Alliance), 2010
Pratt & Whitney TF33 P9 engines once mounted on a Boeing EC-135 surveillance plane, Effexor, Citalopram, and Manitol
Dimensions variable
Courtesy of the Bluhm Family Terrace and the artist
Untitled, 2005–10
Bench, fire and youth
Dimensions variable
Courtesy Corvi-Mora, London

Ian Kiaer

Endnote, pink (black), 2010 (detail)
Tissue, lighting gel mounted on board with aluminium frame, plastic, rubber, acrylic sheet, mounted cotton, perspex
Dimensions variable
Courtesy the artist and Alison Jacques Gallery
Photo: W. Petzi

Endnote, pink (black), 2010
Tissue, lighting gel mounted on board with aluminium frame, plastic, rubber, acrylic sheet, mounted cotton, perspex
Dimensions variable
Courtesy the artist and Alison Jacques Gallery
Photo: W. Petzi

Christian Marclay

Crossfire, 2007
Four-channel video projection
8 minutes, 27 seconds looped
Courtesy White Cube

Simon Martin

Untitled (After Alfred Stieglitz), 2009
Black-and-white photograph
Dimensions variable
Courtesy of the artist

Haroon Mirza

Adhān, 2008
Mixed media installation
Dimensions variable
Teixeira de Freitas Collection, Portugal
Courtesy of Lisson Gallery
Paradise Loft, 2009
Mixed media installation including MW by Giles Round and Loft (2010), A2 unlimited edition digital print made in collaboration with David Maclean for Systematic
Courtesy the artist and Lisson Gallery
Photo: Stephen White

David Noonan

Untitled, 2009
Paper collage
38.4 × 29.2 × 3.8

Gail Pickering

Dissident Sunset, 2008
HD Video
8 minutes
Courtesy the artist
Hungary! And Other Economies, 2007
HD Video
18 minutes
Courtesy the artist

Olivia Plender

Poetry Marathon, 2009
Performed as part of 'Park Nights'
Courtesy the Serpentine Gallery
Photo: Mark Blower
The Thames Whale, 2009
Poster
Dimensions variable
Courtesy the artist

Nutmegs, 2009
Poster
Dimensions variable
Courtesy the artist

Karin Ruggaber

Relief #53, 2008
Concrete, plaster, pigment
41 × 33 × 4
Courtesy the artist and greengrassi, London

Edgar Schmitz

Some Disappearances and a Bit of Noise, 2009
Colour video, 2 minutes 25 seconds, looped, and stereo sound, 3 minutes 49 seconds, looped
Courtesy the artist and FormContent, London

Maike Schoorel

Installation shot containing *Emma-Louise from Above*, 2008 (left); *Monica in her Living Room*, 2008 (right)
Courtesy the artist and Maureen Paley, London

George Shaw

Study for 'Your End', 2010
Enamel on card, 29.4 × 41.1
Courtesy the artist and Wilkinson Gallery

Sue Tompkins

Grease, 2006
Live performance and scripts
Performed at Art Now, Duveen Galleries, Tate Britain, December 2006
Courtesy of the artist and The Modern Institute/ Toby Webster Ltd, Glasgow

Tris Vonna-Michell

Leipzig Calendar Works, 2010
From the work *Leipzig Calendar Works*, 2005–ongoing
Still from performance at Projekt Kaufhaus Joske, Leipzig, 12 May, 2010
Courtesy the artist
Photo: Carsten Humme
Seizure, 2007–8
From the work *hahn/huhn*, 2003–ongoing
Dimensions variable
Courtesy the artist
Photo: Stefan Altenburgerfvertical

Biographies

Charles Avery was born in Scotland in 1973 and lives and works in London. Recent solo exhibitions include shows at the Kunstverein, Hanover, Le Plateau, Paris (both 2010), Boijmans Van Beuningen, Rotterdam (2009) and the Scottish National Gallery of Modern Art (2008). His work has also appeared in major group exhibitions at Tate Britain, the Hayward Gallery, BALTIC Centre for Contemporary Art, Gateshead (2009), the Scottish Pavilion at the 52nd Venice Biennale and the 9th Lyon Biennial (both 2007).

Becky Beasley was born in the UK in 1975 and lives and works in Antwerp and London. Her work was recently shortlisted for the MaxMara Art Prize for Women and has been included in group exhibitions at MACBA, Barcelona, Fotomuseum Winterthur, Kunsthalle Bern (all 2009) and Kunsthalle Basel (2008). In 2010 she was commissioned to produce a live event for the Serpentine Gallery Summer Pavilion.

Karla Black was born in Alexandria, Scotland in 1972 and lives and works in Glasgow. She has had recent solo exhibitions at Kunsthalle Nuremberg (2010), Inverleith House, Edinburgh, Modern Art Oxford and the Migros Museum, Zurich (all 2009). Upcoming exhibitions include the Scottish Pavilion at the 54th Venice Biennale (2011).

Juliette Blightman was born in Farnham in 1980 and lives and works between Berlin and London. She has just completed a residency programme at IMMA, Dublin where her work was also shown, following recent group exhibitions at Staatlichen Kunsthalle, Baden Baden (2009) and at the Institute of Contemporary Arts, London in *Nought to Sixty* (2008). She has also had a recent solo exhibition at Künstlerhaus Stuttgart (2010).

Varda Caivano was born in Buenos Aires in 1971 and lives and works in London. Her work has been shown in group exhibitions at the National Museum of Art, Osaka (2010), Suntory Museum, Osaka and Whitechapel Gallery, London (both 2009), the CCA Andratx Art Centre, Mallorca and the Busan Biennial (both 2008) and in solo exhibitions at the Chisenhale Gallery, London (2007) and the Kunstverein Freiburg (2006).

Duncan Campbell was born in Dublin in 1972 and lives and works in Glasgow. Recent exhibitions include solo shows at Model Arts, Sligo, Tramway, Glasgow, Chisenhale Gallery, London, the Scottish Gallery of Modern Art, Kunstverein Munich and the MUMOK, Vienna (all 2009), as well as a group show at Museo Nacional Centro de Arte Reina Sofia (2009). Campbell is a recipient of the Paul Hamlyn Award and the Baloise Art Prize (both 2008).

Spartacus Chetwynd was born in England in 1973 and currently lives and works in South London. In addition to recent solo exhibitions at Le Consortium, Dijon (2008), the Migros Museum, Zurich and Studio Voltaire, London (both 2007), Chetwynd also participated in *Altermodern: 4th Tate Triennial of British Art*, Tate Britain (2009) and group exhibitions at the Barbican Art Gallery (2008), Creative Time, New York and South London Gallery (both 2007).

Steven Claydon was born in London in 1969 and has participated in recent group exhibitions at Haus der Kunst, Munich (2010), Tate St Ives (2009) and the Busan Biennial (2008), as well as solo presentations at the Serpentine Pavilion (2008), International Project Space, Birmingham (2007) and White Columns, New York (2006).

Cullinan Richards is the artist duo Charlotte Cullinan and Jeanine Richards, who have worked together since 1997 and are currently based in London. Recent solo exhibitions include those at The Lab, Dublin and the Laing, Newcastle (both 2010), Concrete at the Hayward Gallery (2009), Mead Gallery, Warwick Art Centre and Charles H. Scott Gallery, Vancouver (all 2008), as well as group exhibitions at the Whitechapel Gallery, London, CCA Andratx, Mallorca (both 2009) and the Whitstable Biennial (2006).

Matthew Darbyshire was born in Cambridge in 1977 and lives and works in Kent. He has had recent solo exhibitions at the Hayward Project Space, Outpost, Norwich (both 2009), the Institute of Contemporary Arts and Gasworks, London (both 2008), and has participated in group exhibitions at Tate Britain, Sadlers Wells, London and Platform, Seoul (2008–9). In 2010 he was commissioned to produce a project for the Frieze Foundation.

Milena Dragicevic was born in Knin, Croatia in 1965 and lives and works in London. Her work has been shown in exhibitions at The Pump House, London (2008), De Hallen, Haarlem (2007), the Institute of Contemporary Arts, London (2005) and The Yugoslav Biennial of Young Artists, Vrsac (2004).

Luke Fowler was born in Glasgow in 1978. He has had recent solo exhibitions at the Serpentine Gallery, London, CAC Bretigny and X Initiative, New York (all 2009) and participated in group exhibitions at the Barbican Art Gallery, London, Dundee Contemporary Arts, the Scottish National Gallery and the New Museum, New York (all 2009).

Michael Fullerton was born in Scotland in 1971 and is currently based in Glasgow. He has recently shown works in solo exhibitions at the Chisenhale Gallery, London (2010), Tate Britain and Centre for Contemporary Arts, Glasgow (both 2005), as well as in group shows at the Bielefelder Kunstverein (2010), Tramway, Glasgow (2008) and the South London Gallery (2007).

Alasdair Gray was born in Glasgow in 1934 and continues to live and work there. Recent solo exhibitions of his work have been held at the Talbot Rice Gallery, Edinburgh and The Scottish National Gallery of Modern Art (both 2010). Group shows in 2009 included exhibitions at the Institute of Contemporary Arts, London and Rank, Northern Gallery for Contemporary Art, Sunderland. 2014 will see a major retrospective of his work across Glasgow Museums.

Brian Griffiths was born in Stratford-upon-Avon in 1968 and lives and works in London. He has participated in recent group exhibitions at The Mattress Factory, Pittsburgh (2010), Tate Britain, CAPC, Bordeaux (both 2009) and Art on the Underground (2007). In recent years the A Foundation, Liverpool, Camden Art Centre, London and the Arnolfini, Bristol have hosted solo presentations of his work.

Roger Hiorns was born in Birmingham in 1975. He has had solo exhibitions with The Art Institute of Chicago (2010), Artangel, London (2008), Camden Arts Centre, London (2007) and Milton Keynes Gallery (2006). His work has been shown in group exhibitions at Centro di Cultura Contemporanea Strozzina, Florence (2010), De Hallen, Haarlem and the Walker Art Center, Minneapolis (both 2009).

Ian Kiaer was born in London in 1971 and lives and works in London. Recent solo exhibitions of his work have taken place at the Kunstverein Munich (2010), Bloomberg Space, London and GAM, Turin (2009), with contributions to group exhibitions at 10th Lyon Biennial, Tate Britain and Kettle's Yard, Cambridge (all 2009), the Kunstlerhaus, Stuttgart, and the Museum of Modern and Contemporary Art, Bolzano (both 2008).

Anja Kirschner (b. Munich 1977) and **David Panos** (b. Athens 1971) are currently based in London. Their work has recently been shown at the Centre for Contemporary Arts, Glasgow, Chisenhale Gallery, London, Badischer Kunstverein, the Kölnischer Kunstverein and the Athens Biennial (all 2009). Kirschner and Panos were recent recipients of the Film London Artists Moving Image Network (FLAMIN) Productions Award.

Sarah Lucas was born in London in 1962. She has recently exhibited work at the Museum of Cycladic Art, Athens, Snape Maltings, Suffolk, and Pinchuk Art Centre, Kiev (all 2010). Lucas has shown internationally in numerous solo and group exhibitions, with a major touring retrospective at the Kunsthalle Zurich, Kunstverein Hamburg and Tate Liverpool in 2005.

Christian Marclay was born in California in 1955 and lives and works in London and New York. He has exhibited widely, including solo exhibitions at Whitney Museum of American Art (2010), Musée d'Art Moderne et Contemporain, Geneva (2008), Cité de la Musique, Paris (2007), Moderna Museet, Stockholm (2006), Barbican Art Gallery, London (2005), Seattle Art Museum (2004), Tate Modern, London (2004) and UCLA Hammer Museum, Los Angeles (2003).

Simon Martin was born in Cheshire in 1965 and lives and works in London. Recent exhibitions include solo presentations at Kunstverein, Amsterdam (2010), Bass Museum of Art, Miami, Chisenhale Gallery and Tate Britain (all 2008) and group exhibitions at the Centre for Contemporary Arts, Glasgow, Picture This, Bristol and the Whitechapel Gallery as part of the Jarman Award Tour, for which he was nominated in 2009.

Nathaniel Mellors was born in Doncaster in 1974 and currently lives and works in Amsterdam. Recent solo exhibitions include *The 7 Ages of Britain Teaser* at MONITOR, Rome (2010), *Giantbum* at the Stedelijk Museum Bureau, Amsterdam and *The Time Surgeon* at South London Gallery (both 2009). Recent group exhibitions include *Altermodern: 4th Tate Triennial of British Art* at Tate Britain (2009), *Manifesto Marathon* at the Serpentine Gallery (2008) and the 9th Lyon Biennial (2007).

Haroon Mirza was born in London in 1977 and is currently based in Sheffield. His first solo exhibition was staged at the A Foundation, Liverpool in 2009. Since then he has been short-listed for the 2010 Northern Art Prize and participated in group exhibitions at SMART Project Space, Amsterdam and Art Sheffield 10 (both 2010). Mirza is currently Artist in Residence at the Fire Station, ACME Studios, London and on the Board of Directors for New Contemporaries.

David Noonan was born in Ballarat, Australia in 1969 and is currently based in London. He has participated in numerous group exhibitions, including shows at Tate St Ives and Tate Britain (both 2009), Centre d'Art Contemporain, Pougues-les-Eaux, Paris and the 6th Busan Biennial (both 2008) as well as solo exhibitions at the Australian Centre for Contemporary Art (2009) and Chisenhale Gallery, London (2008).

The Otolith Group is the collaborative project of Anjalika Sagar (b. 1968) and Kodwo Eshun (b. 1967), who currently live and work in London. A recent solo exhibition of their work was held between Gasworks and The Showroom, London (2009) and their work has recently been screened at Tate Britain and the Living Art Museum, Reykjavik (both 2006). The Otolith Group has been nominated for the 2010 Turner Prize.

Mick Peter was born in Berlin in 1974 and lives and works in Glasgow. Prior to recent solo exhibitions at The Changing Room, Stirling, Cell Project Space, London and the Salle de Bains, Lyon (both 2010), the artist participated in group exhibitions at CAPC, musée d'Art contemporain de Bordeaux and the Musée d'art contemporain de Lyon (both 2009), Outpost, Norwich (2008) and the Centre for Contemporary Arts, Glasgow (2005).

Gail Pickering lives and works in London. Recent exhibitions, performances and screenings include presentations at the Royal Academy of Arts, the 10th Baltic Triennial of International Art, Whitechapel Art Gallery, London (all 2009), Arnolfini, Bristol, the Institute of Contemporary Arts, London, South London Gallery, Gasworks, London, Tate Modern, London, Palais de Tokyo, Paris, Kunstverein Stuttgart (all 2008), the Musée d Art Contemporain, Marseille (2007) and Matt's Gallery, London, (2004).

Olivia Plender was born in London in 1977 and lives and works in Berlin. She has shown work in group exhibitions at Tate Britain and MACBA Barcelona, the Living Art Museum, Reykjavik (all 2009) and the Hessel Museum of Art, CCS Bard, New York (2008) as well as solo presentations at Gasworks, London (2009), Art In General, New York (2008), Marabou Park Annex, Stockholm (2007) and the Frankfurter Kunstverein (2006).

Elizabeth Price was born in Yorkshire in 1966 and is currently based in London. She has recently participated in group exhibitions at Project Arts Centre, Dublin, Eastside Projects, Birmingham (both 2009), Kunsthalle Basel and Camden Arts Centre (both 2008) with solo exhibitions at Spike Island, Bristol (2009) and the Stanley Picker Gallery, London (2007).

Karin Ruggaber was born in Germany in 1969 and lives and works in London. She had a solo exhibition at Tate Britain in 2006, and has recently participated in group exhibitions at V22, London (2009), the Domaine Departemental de Chamarande, France (2008), East International, Norwich (2007), and the Hayward Gallery (2006).

Edgar Schmitz was born in Germany in 1968 and currently lives and works in London. Schmitz has recently shown work at FormContent, London (2010, 2009), Kunstverein Dusseldorf (2008), the Van Abbemuseum, Eindhoven, the Palais des Beaux Arts, Brussels and at the Institute of Contemporary Arts, London with Liam Gillick (all 2006).

Maaike Schoorel was born in the Netherlands in 1973 and is based between London and Amsterdam. Schoorel has exhibited widely with a recent solo exhibition at Museum De Hallen in Haarlem (2008), and group exhibitions at Parasol Unit, London (2009), Stedelijk Museum, Amsterdam, Project Arts Centre, Dublin (both 2008), De Appel, Amsterdam and the Athens Biennial (both 2007).

George Shaw was born in Coventry in 1966 and currently lives and works in Devon. He has recently shown work in solo exhibitions at Void Gallery, Derry (2010), Kunstverein Freiburg (2007) and the Centre d'Art Contemporain, Geneva (2006), as well as in group exhibitions at the Djanogly, Nottingham (2010), the Whitworth Art Gallery, Manchester and the Sainsbury Centre for the Visual Arts, Norwich (both 2009).

Wolfgang Tillmans was born in Remscheid, Germany in 1968 and lives and works in London and Berlin. He has had solo exhibitions at the Serpentine Gallery, London (2010), the Stedelijk Museum, Amsterdam (2008-9), Hamburger Bahnhof Museum für Gegenwart, Berlin, Museo Tamayo, Mexico City (both 2008), the Hirshhorn Museum and Sculpture Garden, Washington, D.C., Kunstverein Munich (both 2007), as well as the Hammer Museum, Los Angeles, the Museum of Contemporary Art, Chicago and P.S.1 MOMA, New York (all 2006). He was selected by Daniel Birnbaum to exhibit in 'Making Worlds' as part of the 53rd Venice Biennial.

Sue Tompkins was born in Leighton Buzzard, Bedfordshire, in 1971 and currently lives and works in Glasgow. She has participated in numerous group exhibitions including shows at the Whitechapel Gallery, London (2010), Nam June Paik Art Centre, Seoul, the Athens Biennial and the Institute of Contemporary Arts (all 2009), Kunsthalle Basel (2008), the Frankfurter Kunstverein and The Showroom, London (both 2007).

Phoebe Unwin was born in Cambridge in 1979 and is now based in London. She had a solo exhibition at the Milton Keynes Gallery (2007) and has participated in recent group exhibitions at the Saatchi Gallery, London, Galerie IFF, Marseille, Centre for Contemporary Art, Lausanne (all 2010), Jerwood Space, London, PDC – MOCA, Los Angeles (both 2009), CCA Andratx Art Centre, Mallorca (2008), The Corridor, Iceland and W139, Amsterdam (both 2007).

Tris Vonna-Michell was born in Rochford, Essex in 1982 and is currently based in Sweden. A recipient of both the Baloise Art Prize and Ars Viva Prize in 2008, Vonna-Michell has recently shown and performed work at Focal Point, Essex, Guggenheim, New York (both 2010), Kunsthalle Zurich and the Kölnischer Kunstverein, as well as at Creative Time, New York, New Museum, New York, the Museum of Contemporary Art, Detroit (all 2009) and Witte de With, Rotterdam (2007).

Emily Wardill was born in England in 1977 and lives and works in London. She has had recent solo exhibitions at De Appel, Amsterdam, The Showroom, London, Spacex, Exeter and the Altman Siegel Gallery, San Francisco (all 2010). Her work has been shown in group exhibitions at Tate Britain, the Museum of Contemporary Art, Miami (both 2009), the Serpentine Pavilion, London, Kunsthalle Basel and the Institute of Contemporary Arts in Perth (all 2008).

Keith Wilson was born Birmingham in 1965 and lives and works in London. Recent solo exhibitions have been held at venues including the Wellcome Collection, London (2010), Eastside Projects, Birmingham and Outpost, Norwich (both 2009), Art on the Underground (2008) and Milton Keynes Gallery (2004). He has appeared in group exhibitions at the Hayward Project Space (2009) and the Institute of Contemporary Arts, London (2008).

Acknowledgements

Many people have contributed to the realisation of this exhibition and in addition to the curators and artists we owe thanks especially to the lenders: Art on the Underground; Arts Council Collection, Southbank Centre, London; John and Odile Connolly, London; Wilfried & Yannicke Cooreman – De Smedt; LUX, London; Julian & Victoria Martin; Collection Soonieus, The Netherlands; Collection Thaddaeus Ropac, Paris – Salzburg; Tapestry Foundation of Victoria; Tate; and all those who wish to remain anonymous.

The *British Art Show* has been organised by Hayward Touring at the Southbank Centre, London. Exhibition Organiser: Isobel Harbison; Assistant Curators: Vanessa North and Hattie Spires, supported by Jessica Cerasi, Susanna Davies-Crook, Rahila Haque and Nadia Thondrayen. Technical team: Dave Bell, Pete Brown, Steve Bullas, Mark King, Matt Nightingale, Dave Palmer, Amy Simpson, John Wallace, Eddie Smith; Registrars: Miriam Hirschfield, Alison Maun, Imogen Winter; Hayward Publishing: Amy Botfield, Deborah Power, Mary Richards, Faye Robson; Press: Gilly Fox; Marketing: Helen Faulkner, Gaelle Lochner, Edward Venning, Selena Virrels.; Hayward Gallery General Manager: Sarah O'Reilly; Interpretation: Helen Luckett; Learning and Participation: Becca Connock, Lucy Jefferies, Shan Maclennan. Other colleagues at the Southbank Centre who have contributed include: Gerry Cahill, Nick Caine; Melford Deane; Anna Johnson; Sarah Sawkins; Jon Smalldon; Rebecca Smith; Trish Thomas.

Independent technicians, writers and designers have also provided essential support: Tom Cullen, Dian Hall, Jem Legh, David Leister, Brian Macken, Philip Miles and Katrina Schwarz.

We thank the following colleagues in the cities on the tour:

Nottingham

New Art Exchange: Skindar Hundal, Andy Lindley, David Schischka Thomas, Mark Stephens, Raam Tarat; Nottingham Castle Museum and Art Gallery: Tris Aver, Anne Coyne, Deborah Dean, Ron Inglis, Russell Jenkins, Jo Kemp; Nottingham Contemporary: Rob Blackson, James Brouwer, Alex Farquharson, Vicky Godfrey, Lynn Hanna, Saima Kaur, Bo Olawoye, Fiona Parry, Daniella Rose King, Abi Spinks, Dave Thomas, Helena Tomlinson, Jim Waters; Michelle Bowen, British Art Show Co-ordinator, Nottingham.

Arts Council England, East Midlands: Alison Lloyd, Sarah Reed; BASIC: Anna Carlisle, Rachael Evans, Ashika Fenton, Rosny Hayward, Jenna Stevens; Experience Nottinghamshire: Lizzie Carr; Nottingham City Council: Marisa Blissett, Frances Howard, Dominic Miller and team; Nottingham City Transport: Ian Combellack; Nottingham Trent University; Rare Company: Gemma Hose, Zeta Fitzpatrick; Sideshow: Candice Jacobs; Jennie Syson.

London

Hayward Gallery: Assistant Curator, Charu Vallabhbhai; Hayward Designer, Michael Vale; Learning and Participation, Rafal Niemojewski.

Glasgow

Centre for Contemporary Art: Julie Cathcart, Francis McKee, Kerri Moogan; Gallery of Modern Art: Katie Bruce, John Ferry, Victoria Hollows, Sean McGlashan; Tramway: Stuart Gurden, Claire Jackson, Rosemary James, Sarah Munro, Lorraine Wilson.

Creative Scotland: Amanda Catto; Event Scotland: Lorna Campbell, Rhona Corscadden, Alan Grant; Glasgow Life: Charles Bell, Julia Craig, James Docherty, Calum Guthrie, Janice Lane, Kirsten McGurk, Kirsten Tuttle; Glasgow School of Art: Jenny Brownrigg, Professor Seona Reid; Glasgow City Marketing Bureau: Elaine Dickie, Lorna Graham; The Common Guild: Kitty Anderson, Katrina Brown.

Plymouth

Peninsula Arts Gallery, University of Plymouth: Sarah Chapman, Simon Ible, Liz Wells; Plymouth Arts Centre: Ian Hutchinson, Caroline Maudsley, Paula Orrell, Kate Sparshatt; Plymouth City Museum and Art Gallery: Jo Clarke, Adam Milford, Nicola Moyle, Judith Robinson.

Architecture Centre Devon and Cornwall: Tanya Griffiths; Arts Council England: Carla Hiley, Ceri Johnson, Simon Jutton, Mariam Sharp; Barefoot: Richard Marsh; Audiences South West: Alicia Miller; Faculty of Arts, University of Plymouth: David Coslett; Groundwork: Ray White; i-DAT Centre of Expertise, University of Plymouth: Mike Phillips, KURATOR, University of Plymouth: Joasia Krysa, Magda Tyzlik-Carver; Plymouth City Council: Peter Brookshaw, James Coulton, Kath Davies, Vivien Pengelly; Plymouth College of Art & Design: Malcom Ferris, Hannah Jones; Plymouth Visual Arts Consortium: Oliver Flexman, Trystan Hawkins, Ryan Rogers, Kyle Turner; Urban Splash: Nathan Cornish, James Howard, Emily Jones.

Further credits

The galleries and studios of the participating artists helped in many ways with this exhibition. In particular, we are grateful for the assistance of the following: Alison Jacques Gallery; Antonia Syme, Australian Tapestry Workshop; Ronnie Black; Steven Bloomfield; Carl Freedman Gallery; James Clarkson; Anna Clifford; Pilar Corrias Gallery; Corvi-Mora Gallery; Galerie Crèvecœur; Galerie Diana Stigter; De Hallen, Haarlem; Dennis Van Doorn; doggerfisher; Elizabeth Dee; greengrassi; Herald St; Hollybush Gardens; HOTEL; Galerie Jan Mot; Martin Johnson; Reindier Kranendonk; Stephan Kuderna; Laura Bartlett Gallery; Lisson Gallery; LUX; Federico Martelli; Galerie Martin Janda; Mary Mary Gallery; Matt's Gallery; The Modern Institute; Maureen Paley; MOT International; Pavel Pys; Sadie Coles HQ; Willow Schade; Owen Smith; Sorcha Dallas; Victoria Miro Gallery; Vilma Gold; Jonathan Viner Gallery; Tjalling Visser; White Cube; Wilkinson.

We also thank the following individuals: Philip Abraham; Craig Burnett; James Cahill; Susanna Chisholm; Axel Dibbie; Tamsin Dillon; Andrew Hamilton; Chris Hammond; Xander Karskens; Lisa Panting; Clare Fitzpatrick; Darren Flook; Jackie Daish; Chris Jacob; Robin Klassnik; Elisabeth Konrath; Eva Lahnsteiner; Melissa Larner; Gil Leung; Elizabeth Manchester; Lucy Moore; Anna Mustonen; Hannah Robinson; Elisa Sjelvgren; Malin Stahl; Jessica Vaughan; Toby Webster.

The curators have benefited from conversations with a number of people and would particularly like to acknowledge David Annand; Caroline Arscott; Oliver Basciano; Nicolas Bourriaud; JJ Charlesworth; Sarah Conway; Judith Crowe; Lindsay Evans; Dan Fox; Jonathan Griffin; Lyn Harris; Fatima Hellberg; Rebecca Hellen; Jennifer Higgie; Ludmilla Jordanova; Uta Kogelsberger; Marysia Lewandowska; Melanie Manchot; Andrea Medjesi-Jones; Jack Morton; Katie Morton; Clair O'Leary; Andrew Renton; Rose Scott; Skye Sherwin; Polly Staple; Martin Thomas; Sam Thorne; Gilda Williams; and the staff and students on the Curatorial Programme at Goldsmiths College.

As always, during the research phase the *British Art Show* draws on the informed advice and recommendations of colleagues in arts organisations around the country, and we thank particularly: David Bethal, AirSpace Gallery, Stoke-on-Trent; Nav Haq and Tom Trevor, Arnolfini, Bristol; Katy Woods, Art, Sheffield 2010; Alessandro Vincentelli and Godfrey Worsdale, BALTIC, Gateshead; Bryan Biggs and Sara-Jayne Parsons, Bluecoat, Liverpool; Alan Haydon, De La Warr Pavilion, Bexhill-on-Sea; Graham Domke and Judith Winter, Dundee Contemporary Arts; Gavin Wade, Eastside Projects, Birmingham; Andrew Hunt, Focal Point Gallery, Southend-on-Sea; Jon Wood, Henry Moore Institute, Leeds; Helen Legg and Nigel Prince, Ikon, Birmingham; Declan McDonagle, Interface / NCAD, Belfast; Tanja Pirsig-Marshall, Leeds Art Gallery; Jon Bewley, Locus +, Newcastle-Upon-Tyne; Gavin Delahunty, Middlesborough Institute of Modern Art; Alistair Robinson, Northern Gallery for Contemporary Art, Sunderland; Feargal O'Malley, Ormeau Baths Gallery, Belfast; Pippa Hale, Project Space, Leeds; Louise Clements, QUAD, Derby; Fareda Khan, Shisha, Manchester; Carol Maund, Site Gallery, Sheffield; Anne-Marie Quay, Spike Island, Bristol; Sarah Martina, Turner Contemporary, Margate; Mary Griffiths, The Whitworth Art Gallery, Manchester.